PARANORMAL
STAFFORDSHIRE

PARANORMAL
STAFFORDSHIRE

Anthony Poulton-Smith

AMBERLEY

First published 2011

Amberley Publishing
The Hill, Stroud
Gloucestershire GL5 4EP

www.amberleybooks.com

British Library Cataloguing in Publication Data.
A catalogue record for this book is available from the British Library.

ISBN 978-1-4456-0336-0

Typesetting and Origination by Amberley Publishing.
Printed in Great Britain.

INTRODUCTION

My personal experience with the paranormal is limited to one brief ghostly glimpse that is now so many years in the past that the memory is little more than a haze. Indeed I can no longer describe more than the outline of the figure in question.

In 2008 I was lucky enough to be given the opportunity to research a book on the paranormal in the Cotswolds. Having delighted in the people I met and the places I visited during my year of research, I was keen to produce another volume as soon as possible. My thanks to the editorial staff at Amberley Books for unleashing me on not one but two further paranormal trails – around Birmingham and across my native Staffordshire.

Having completed the research and interviewed dozens of individuals I still have an open mind. Many of those I spoke to fervently believe their experiences can only be explained as paranormal events and nothing will persuade them otherwise. I am still to be convinced such phenomena exist.

Many hours of searching and numerous appeals have produced many narratives, including the traditional tales that are now a part of folklore and simply cannot be omitted. Others, both contemporary and historical, have never before appeared in print. Even if I have yet to be convinced, there can be no doubt the stories are among the most fascinating ever told – and that, surely, is the attraction. Indeed it is not only *what* occurred but *to whom*. The people themselves bring these stories to life.

Within these pages we will visit everything from castles to the modern semi-detached. We will meet the nobility, the lowliest servants, babes in arms, the elderly, faithful pets, and wild animals. Our journey will takes us from the Potteries in the north to Cannock Chase in the south, and on the way we will visit the population centres of Lichfield, Tamworth, Stone, Stafford, Newcastle-under-Lyme and Burton-upon-Trent.

It is interesting to note how many of these stories are set in public houses and churchyards. Whether this is due to the strength of the beer and the eerie silhouettes of gravestones is for the reader to decide. On the other hand, perhaps these are simply the most common meeting places after sunset.

While the pages that follow contain several horror stories, in truth few of the manifestations could be regarded as malevolent. Most of those I met could offer no explanation for their experience, although, interestingly, some remained sceptical, others amused. There are those who remain completely indifferent.

No matter what the encounters are – whether tricks of the light or the mind – is not relevant here. This book is intended solely to record the narratives, both traditional and contemporary. It is for you, the reader, to make up your mind in each case.

A

ABBEY HULTON

A Deal with the Devil

A relatively poor monastic holding, Abbey Hulton relied solely on its agriculture, its sheep rearing and its tannery. The establishment closed its doors for the last time, with barely a whimper, in 1538.

However, this was not the end of the religious connection. Our story starts some time later, in the eighteenth century. A monk by the name of Robert was so disappointed with his life that he entered into a pact with Satan himself. Robert agreed to sell his soul to the Devil and, in return, went on to become Lord of Hulton Vale.

However, unbeknown to Robert, the old abbot was to be given a prominent position at York. Asked who should replace him, the abbot put forward Robert's name and this recommendation was accepted. The abbot decided to withhold the news for a short while, planning to pass on the news on Christmas Day as the best kind of gift he could offer.

Predictably, the news filled the monk with great remorse and Robert sought help and guidance from a holy hermit of nearby Bagnal. But if Robert sought forgiveness he was to be disappointed, for the hermit made sure he was aware that what he had done was an unforgivable sin. The hermit refused to give Robert absolution and told him to return to Hulton Abbey, take up his new duties, perform them to the very best of his ability, and lead a life utterly without sin. Should he achieve this, the Devil's influence would fade.

Robert followed the hermit's instructions to the letter until his death some years later. However, his true punishment would follow his death, and his spirit was forced to wander the valley for a thousand years before he could finally enter heaven. Just over two hundred years have now passed and Robert is still said to roam these lands. He has plenty of time to consider his actions and to regret his impatience.

ABBOTS BROMLEY

The Coach and Horses
During the 1960s, a worker for Ordnance Survey arrived from Southampton on business. He booked a room at the Coach and Horses but requested a new room very soon after seeing a strange and indistinct shape in the bed...

The Royal Oak
While there have been reports of the unexplained since 1955, nothing had been written down until the arrival of new licensees in 1981. Husband and wife Garnet and Jean Carter's first year passed without incident, but in March 1982 everything changed.

It was not only the management and staff, but customers too who noticed the strong smell of violets in the pub. Others reported the distinctive aroma of pipe smoke. While smoking was still allowed in pubs at that time, this was difficult to explain as no pipe smoker had been near the place.

One morning while talking to a customer in the pub's lounge, the Carters saw a small blonde girl near the top of the cellar steps. This was not someone any of them knew – indeed the figure was not entirely whole. While her head and shoulders appeared quite solid, the lower one looked the more she appeared to be nothing but a mist. A few days later same girl was observed by a different customer.

Shortly afterwards, Jean was with her husband and their daughters in the pub after closing time. They distinctly heard the sound of children playing upstairs in the living quarters. Upon investigation, nothing was found.

The most unnerving experience for the landlord was when he was talking to several customers during a quiet period. His attention was drawn to a black cat walking slowly and arrogantly – as only a feline can – across the room. The publican had never had a cat and just as the question as to how it had got in to room was raised, the animal promptly vanished.

An earlier story involved the clearance of the attic. An employee opened the door to the topmost room and was confronted by a character with a long very white beard and a cloak. The employee summoned assistance to deal with the 'intruder', but when he returned to the attic nobody could be found.

A few days later the bearded man was seen a second and final time, accompanied by an eerie music that filled the inn. There was no explanation of the source.

ALTON

Alton Towers
While the name is best known for its theme park, the house has been here since 1860 and the earliest known settlement, an Iron Age hill fort, dates from 3,000

years ago. Around AD 700 the Saxon Ceolred, king of Mercia, had a fortress here. The Norman castle built here four centuries later was destroyed during the English Civil War.

The gardens were started in the early nineteenth century by Charles Talbot, the 15th Earl of Shrewsbury. Over ten years some 13,000 trees were planted and in 1811 major work began on the house. The additional rooms doubled the size of the house, which was also renovated in the Gothic style. Thereafter the gardens were extended, taking in much of the land, which had previously been farmland. When Charles died, the work was carried on by a succession of heirs – first nephew John, followed by John's cousin Bertram and then distant cousin Henry Chetwynd-Norfolk of Ingestre Hall in Staffordshire.

Most of the work on the house was completed by 1856, after which the grounds were opened to the public. During the Second World War the British Army requisitioned the house as an officer-training centre. After 1951 the grounds were closed and the house fell into disrepair and had to be stripped for safety reasons, leaving just an empty shell. The theme park opened in 1980, rapidly expanding in its early years. New attractions have been added almost every year.

For some time the house has been associated with ghosts and legends; some of the rides are even based on these tales. Hex is a reminder of a curse said to have been put on the family of the 15th Earl. During one of the lavish parties he became known for, celebrations were interrupted by an old man in dirty rags claiming he was a travelling fortune teller. He hoped he could earn a penny by telling the fortunes of some guests, but this was not to the Earl's liking and the stranger was ridiculed by the guests and dismissed. However, he silenced the crowd when he turned and promised that every branch that fell from the great oak in the grounds would result in the death of a member of the family. The next day the Earl inspected the tree and ordered the gardeners to support every branch with strong chains. These chains can still be seen supporting the branches of the great oak today.

The focus of the sightings has been the house itself. In the vicinity of the music room the figure of a large man has been seen several times. Heavy footsteps have also been heard there, although it is unclear if the two are connected. In what had been the banqueting hall, more footsteps have been heard and, again, another dark, shadowy individual has been seen. The most commonly sighted is the lady walking the corridors in her long black dress – her appearance often accompanied by a heady aroma of perfume.

During a recording of the television show *Most Haunted* it was suggested that the music room was the haunt of a particularly aggressive hooded man and that the perfumed woman was a former governess. There was also a purported incident of stone-throwing during filming – something also reported by visitors to Alton Towers.

AUDLEY

The Boughey Arms

During the winter of 1974/75, new licensees Roger and Iris Mayer played host to a non-paying guest. It was not so much the husband and wife who were troubled, but rather their eight-year-old West Highland White Terrier, the family dog, rather appropriately called Whisky.

Landlady Iris was certain the ghost was female – 'What male would bother to draw back the curtains?' she often asked. It seems the ghost was most active in the living quarters and in the sitting room in particular, where the curtains had been found pulled back on a number of mornings. Whisky would not be left alone in this room. She growled, bared her teeth, stared at the ceiling and even howled her displeasure. However, she would usually settle down and took to sleeping in her favourite position – ironically beneath the very window where the curtains seemed to have a mind of their own. Yet as soon as the family retired for the night and shut off the light she would be out of that room before the door was closed.

At the time of these troubles the pub was undergoing a major £20,000 refurbishment. Such changes are often cited as the catalyst for ghostly activity, and there were no reports following completion of the work.

Soon after the story appeared in a local paper, a sharp-eyed patron of the Old Robin Hood in Norton recognised the couple as the former licensees of his local. He said that Roger and Iris Mayer had been plagued by an unseen visitor once before, in the mid-1960s. This time the pub was not simply refurbished, but demolished and rebuilt. The ghostly visitor had not been heard of again after the work had been finished.

Was there a link between the two stories, other than the obvious one of the same landlord and landlady? Was it, as some suspected, simply a way of drawing attention to the two pubs in order to attract custom?

B

BLITHFIELD

Blithfield Hall
This is a place that would qualify as the most haunted in Staffordshire if all five reported phenomena were still active.

Home to the Bagot family since the fourteenth century and locally pronounced as 'Bliffield', the present hall is largely Elizabethan with 1820s additions. At the end of the Second World War, the estate and the hall were bought by South Staffordshire Water, who constructed the Blithfield Reservoir, opened by Queen Elizabeth The Queen Mother on 27 October 1953. Still associated with the Bagot family, it is also home to the breed of goat named after them.

Five ghosts have been reported over the years, although two have gone very quiet recently, including the most famous of all, known as the Grey Lady. She wears a long grey gown and a lacy bonnet and carries a bunch of keys. She is thought to be either a member of the Bagot family or a former housekeeper, although there have been no sightings since the early 1970s. Also in the hall there have been reports of rustling clothing, always between 11 p.m. and midnight. Some say it is the unmistakeable sound of a flowing cotton dress; others suggest it is the noise of a priest's robes.

In the drawing room, another form was first seen in 1973. At 3 p.m. on a brightly lit afternoon, two of the cleaning staff entered to see a gentleman standing there. Both mother and daughter described exactly the same thing – a man staring at the floor while fiddling with a very unusual ring on a finger of his left hand. The man was dressed in dark clothing and simply dissipated as he was approached.

Step outside and perhaps you will be lucky enough to see a woman in a long frock, grey shawl and straw bonnet in that part of the garden to the east of the estate where the azalea bushes would have been in full bloom in the spring. She is only seen from a distance, and again she fades away when approached.

The fifth and final report has only ever been heard and, perhaps thankfully, not within living memory. This story dates back 250 years, when a gardener was passing a well and heard the sound of crying coming from the shaft. A small child had fallen into the well and was unable to get out, so the rather elderly man attempted to climb down and effect a rescue. However, he slipped and fell, clanking the chains and screaming in terror as he plummeted to his death.

This well was sealed long ago, yet an old man has been spotted here, slipping down into the ground where no hole or shaft remains visible today. Worse still were the spine-chilling screams emanating from beneath the ground at that very spot.

Blithfield Reservoir
A more recent sighting in Blithfield occurred in 1982. It was a cold, dark and very wintry night, and taxi driver Maggie Owen was driving along the road between the two halves of the reservoir.

Glancing in her rear-view mirror, she noticed someone was sitting in the rear of her black cab. Initially thinking it was her own reflection in the glass partition, she realised this could not be so as the partition was open. The figure, she saw, was unmistakeably male. Absolutely terrified, Maggie accelerated across to the other side of the causeway, whereupon the figure simply vanished.

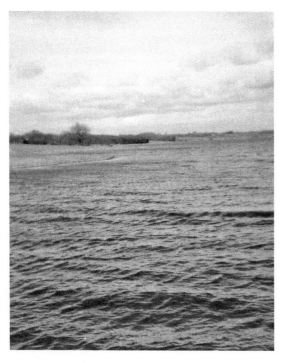

Blithfield Reservoir.

Since that night Maggie had refused to cross the causeway. However, this did not divorce her from spectral phenomena. Back at her home in Rugeley, the houses in John Ball Close had been visited by a monk. Wearing a brown habit, he had been seen walking slowly and silently between the houses, passing directly through the intervening walls and leaving no sign of his passing.

The Springfields Estate seems to have been a magnet for visitors from the other side. Just over a hundred yards away, in Holyoake Place, the children of William and Doreen Smith once felt unseen hands pushing and pulling them when they played in and around their home.

BRERETON

Coal Pit Lane (I)
There can be no doubt as to the origin of this road, but further evidence is provided by the adjoining Colliery Road. However, mining is not the focus here but rather an animal – a black dog that is rapidly becoming known as the Hellhound. In folklore, the sighting of such a creature is often said to be a portent of death.

Several reports have come in over the years, but one stands out from the rest. In 1972, one Nigel Lea saw a ball of light come crashing to the ground. Intrigued, he slowed his vehicle to get a closer look and, to his amazement, was confronted

Coalpit Lane, Brereton.

by a massive black dog. Before the month was out, one of his closest friends died in an industrial accident; Mr Lea fervently believes the dog was in some way connected.

Coal Pit Lane (II)
In July 1980, Mrs Sylvia Everett was a passenger in the car driven by her husband. It had been a pleasant evening – a celebratory meal at a restaurant – and the couple were on their way home to Rawnsley around thirty minutes before midnight.

Approaching a bend, the car's headlights illuminated a high line of trees on the opposite side of the road. From the trees Mrs Everett saw a ribbon of mist emerge. It was no more than 2 feet in depth and approximately 10 feet in length. However, this was no ordinary mist. There was no sign of it dissipating and the form had a clear beginning and end. Furthermore it was a clear, warm night; there should have been no mist at all.

Mrs Everett's first thought was that she had been mistaken. Yet at that moment her husband exclaimed, 'My goodness, did you see that?' Both had seen exactly the same thing.

Coppice Pit Coal Mine
Known locally as 'the Coppy', in the 1880s this was linked to the Flaxley Green Pit a thousand yards to the south-west. The latter had been sunk by the Paget family as a trial shaft thirty years earlier but had been abandoned due to flooding.

In 1902 the Brereton Colliery Company acquired these workings and set about widening and deepening the shafts, once again forming the link between the Coppy and Flaxley Green. This was to prove disastrous for on the night of 15 February 1908 water rushed into the Coppice Colliery, flooding the workings and resulting in the deaths of three miners and five pit ponies.

Within eighteen months all the pits here had been closed. However, over the next sixty years several people living in the road where the pit once was reported hearing the galloping of ponies along the road.

BROUGHTON

Charnes Hall
This place was held by the Yonge family until as recently as 1916. The house is said to be haunted by a woman wearing flowing silken gowns, hence she is known to some as 'Silky'. She is said to be searching for her wedding ring, stolen from her finger by a servant girl as she lay in her coffin; perhaps she is also seeking the thief.

Red Socks

A sixteenth-century Elizabeth manor house, this Grade I-listed building is said to be cursed: no elder son will live to inherit the property. However, it is a particular character that interests us – the rather oddly named Red Socks.

A female servant hailing from Broughton was cleaning the attic staircase leading off the long gallery. Sensing someone above her on the staircase, she looked up to see a young man descending the staircase. Being a well-trained servant, she moved the bucket of now somewhat dirty water to one side in order to let him pass. However, this proved unnecessary, for the young man walked straight through her.

Despite this shock, she did happen to notice his red socks, hence his nickname.

BURNTWOOD

Woodhouses Road

Born in 1922, Ivan was just twelve years old when an innocent game of hide and seek turned into the most chilling experience of his life.

Light was failing and it was getting late. So the group broke up and Ivan and his friend headed off towards their respective homes. Suddenly the pair noticed a tall dark man and a large black dog emerge from a dense hedge not 10 yards away from them. Frozen to the spot, the two watched in terror as both figures walked past them and vanished. Both later noted how during the brief encounter not a sound could be heard – neither from the man walking past nor normal background sounds.

Within the next few days, when the thought of the experience was still making the hair on the back of his neck bristle, he discussed the encounter with a trusted uncle. Amazingly the uncle not only believed him but stated he had seen the same figure himself, on several occasions when he was a younger man. The first time the uncle met the dark figure he was so scared he instinctively lashed out at the man with a stick he was carrying. He certainly did not miss his intended target, but the stick passed right through him.

There have been other witnesses who have reported the same thing, although all these have reported the figure as appearing quite solid. Most often he is seen appearing from the same hedge as witnessed by Ivan; he then walks across to the field and promptly disappears.

BURSLEM

Molly Leigh

In 1685 a girl was born in the Hamil area of Burslem. It is probably true to say she is as well known in her home town today as she was during her lifetime.

Even at birth Molly was said to be very different – deformed and ugly, something difficult to achieve as a baby. It was widely held that her toothless head had eaten stale crusts and suckled the lactating animals of the fields. Her ugliness worsened as she got older and this, coupled with her wild eyes and vile demeanour, made her feared and shunned by the community. It was held that her eyes alone could make a child ill, cause afflictions in adults, even make livestock lame.

Such comments only served to worsen her mood. Thus, as Molly grew she turned to veritable solitude. Her only companion was a black bird (reports of the actual species vary), which perched on her shoulder as she travelled the village with her pail of milk screeching for custom. Even in this she was regarded with suspicion; the locals believed the unscrupulous witch would water down the milk before she sold it.

Each day she returned to her cottage at Jackfield. No one else entered this place, not even her bird, which perched on the roof or the bloomless hawthorn to keep an eye on passers-by. Locals were also wary of the bird, for should it see or hear anyone speaking ill of its mistress it would wait until the offender entered the Turk's Head and then turn the beer sour. The vicar of St John's church, Thomas Spencer, once tried to shoot the accursed bird; for the next three weeks he was racked with pain, unable to rise from his sick bed. Doubtless Molly and her bird were responsible.

The witch's miserable life continued until her death in March of 1748. Burslem rejoiced. No longer could the evil eye of Molly Leigh touch their lives. The funeral was conducted by the Revd Thomas Spencer, and she was laid to rest in the churchyard of St John's. After a glass or two at the Turk's Head to fortify their spirit, the mourners, led by their vicar, headed to Molly's cottage to 'cleanse and purify' the witch's hovel through prayer.

Arriving at the door, the parishioners hung back, allowing their vicar to fling open the door and boldly stride into the gloomy interior. Moments later they stepped back as Spencer fled. They found him in the pub, gulping down more drink. Composing himself, he told them what he had seen. Sitting by the fire, knitting, was Molly Leigh – the woman whose dead body they had recently interred in the grave.

Alive, the witch was feared. Undead she was just too much to contemplate, and so more clergy were summoned. Six of them exhumed her body and performed the exorcism in the churchyard. Instead of the Christian east–west alignment, the body was turned to lie north–south. As the men prayed, they were chilled when a black bird settled on the edge of the newly opened grave. They fled, leaving the Revd Spencer. He swiftly grabbed the bird by the throat and threw the fluttering black creature inside the coffin and dropped the lid before rushing off to join his colleagues.

Later they returned to complete the ceremony at the cottage, praying that the witch would never return to the streets and buildings of Burslem. For a time it seemed her spirit had been laid to rest, until reports of her walking the streets came in both the eighteenth and nineteenth centuries. She was said to be heard chanting, 'Weight and measure sold I ever, milk and water sold I never.'

Anyone brazen enough to circle her grave three times while reciting 'Molly Leigh, Molly Leigh, you can't catch me' will free the witch once more.

BURTON UPON TRENT

The Appleby

It is always a pleasure to discover a different kind of pub and the Appleby fits that bill perfectly. The theme here is goth culture – the dark attire and mood of which are perfect for a ghostly tale.

When husband and wife team Kevin and Michelle Bullock took over the property about five years ago, they had no knowledge of what lay in store for them. Not long after they arrived, Michelle was aware of another unseen visitor. Among her collection of goth paraphernalia is her personal collection of 'living dead' dolls, which are displayed on shelves. She suspected something was amiss when she found the dolls had been rearranged. Her husband Kevin was not so sure, not even when she deliberately stopped dusting the shelves and discovered the tell-tale dust-free rings after the next 'rearranging'.

Kevin was a complete sceptic when it came to ghosts, refusing to acknowledge their existence until one day in 2009 when Michelle was laid up in bed with a particularly debilitating dose of flu. Climbing the stairs to check on how she was feeling, he entered the bedroom to find her sound asleep. However, she was not alone, for at the bottom of the cast-iron bedstead stood a young girl.

Aged around nine, she had long blonde hair and wore a black dress with a white pinafore. As he watched, the girl began to dissolve, starting at the top of her head and ending with her feet, leaving no clue that she had been there. Kevin chose not to wake his wife, not wishing to worry her, and only spoke of the matter when she had risen from her sickbed. Unknown to her husband, Michelle was fully aware of the visitor, which she had named 'Emily'.

As the story of Emily's appearance circulated, one person came forward to describe how the building had been investigated by a paranormal group before the refurbishment; they had reported a girl, too. Furthermore, they had discovered the girl had been called Emily. Michelle feels that because she has always referred to Emily by her real name, the ghost has been content at the Appleby.

The Appleby, Burton upon Trent.

The Burton Mail

In 2004 the staff of the *Burton Mail* called psychic investigators to help them solve a mystery that had plagued them for as long as anyone could remember.

The building is over twice the age of the newspaper. The Bass family moved there in 1756, when it was advertised as 'containing spacious hall, five large parlours, bed chamber, butler's pantry on the lower floor, bed chambers on the second floor, attic storey. Coach-house and stable for eight horses, malt house, brew house, pigeon house, walled garden with fishponds.' All of this for the princely sum of £1,050.

Upon the death of his father in 1787, the house passed to his Michael Thomas Bass, Sr, and then to Michael Thomas Bass, Jr, who developed Bass, Ratcliff & Gretton Breweries and thus required larger premises. This house became home to the Gretton family, until John Gretton moved out between the censuses of 1861 and 1871.

The building makes for ideal offices, although the staff of the twenty-first century were less than certain of this when they called in a local investigation team. The staff only used the lower floors, but they heard the sounds of tables and chairs banging upstairs. Doors slam in the toilets when nobody is inside. Shivers are felt too, although not always in the same part of the building. Some feel a tap on the shoulder from the iciest of hands.

Perhaps some of these occurrences can be explained by the contents of the report by the psychic investigators. Three individuals were found in the main part of the building – a boy by the name of John, a young girl called Emily, and an unnamed tall man wearing a very black suit. In the upstairs rooms, where the servants' quarters were once found, a maid called Emma Butler was clattering about in what had been a kitchen. Finally, in the ladies' toilets, the investigators saw a man wearing a rather dirty white shirt and a scruffy waistcoat. He did not speak but identified himself as a rat catcher by holding up some of the vermin he had caught by their tails.

A search through the census records failed to find any former occupants that fitted these names and descriptions. This does not mean they were not there, simply that they were not recorded in a census – the first of which was performed in 1801.

Sinai House

Sinai House was originally built in the sixteenth century. It is made up of two separate buildings, Grade II-listed, and is a combination of styles, albeit with a largely Elizabethan appearance. There is evidence to suggest this moated site has been inhabited on and off since pre-Roman times 2,000 years ago. A Saxon stronghold was certainly found here, and the moat appears on maps as early as the twelfth century. During the medieval era the lord of the manor used the place as his courthouse.

When the building was given to the monks of Burton Abbey, some sources suggest it was utilised as a sanatorium for sick or elderly monks. Legend has it that a tunnel connected the two, although this is highly improbable as it would have been at least 3 miles long and would not have been a part of the original construction.

Many skirmishes of the English Civil War would have been visible from the building, and it was around this time that the two buildings were joined together, while during the 1730s the bridge over the moat and the plunge pool were rebuilt to give the house a grander, decidedly gothic appearance. It was home to Lord Henry Paget, Earl of Anglesey and Uxbridge, who was Wellington's right-hand man at the Battle of Waterloo.

A story is told of how Paget had his leg shot off while sitting astride his horse, upon which incident Wellington observed, 'Lord Paget, I do believe you've lost a leg.'

Quite calmly, Henry Paget – a well-known lady's man and the subject of numerous stories and poems – responded, 'Sir, I do believe I have.'

After the Pagets fell upon hard times they were forced to sell the property in the early twentieth century. Converted into six cottages, Sinai House was eventually used to house pigs and hens. In 2002 the surrounding area, Sinai Park was planted to become Sinai Wood. The nearby pub, known as 'the gateway to Sinai' and officially known as the Mount Pleasant Inn, predates the Trent & Mersey Canal.

It seems almost inevitable that a building of this age should exhibit some paranormal activity. However, the number and variety of reports is still quite surprising. We should expect to find electrical problems and indeed do, but it is surely rare to find the alarms on parked cars affected.

Occupants have heard knocking on the walls, and those standing in the front doorway have felt invisible hands pushing them inside. There have been reports of the strong smell of smoke, as if the place were on fire. Both owners and their pets have been troubled by unseen figures. The owners report seeing figures in the corner of their vision and shadows passing from room to room, while their pets are disturbed by an unseen presence – they are often to be found staring at nothing, snarling and yowling.

Folklore tells of the Grey Lady of Sinai House, who is said to have been impregnated by a lecherous monk. When he discovered she was with child, he murdered her and buried the body in a neighbouring field. She is said to be seen crossing the bridge over the moat, particularly in those last few hours of New Year's Eve when bells ring to herald the New Year. This bridge was also said to be where the clash of metal had been heard, as if a sword fight were taking place in the darkness.

Driving up to the house, a recent visitor pulled his car to the side of the road to allow a rather large hay cart to pass. Before continuing, the driver looked back to

make sure it was safe to proceed and was amazed to find there was no cart or any vehicle to be seen. This is by no means unique; when the cottages were here there were several reports of a phantom coach and horses pulling up the driveway, heard but never seen. The cottagers were also subjected to a rather worrying episode of crockery being thrown around their kitchens, although fortunately this typical poltergeist activity did not last long.

On more than half a dozen occasions, the Black Dogs of Sinai have been seen in the building. They appear in both dining room and kitchen, are indistinguishable from real dogs, and have been witnessed by at least four different people at different times. It is said the black dogs were once kept by the abbot.

Clearly such a property has been a magnet for paranormal groups and spiritualists. One such group had recently detected an old lady in the attic when a visitor arrived. The guest was not surprised by the report for she maintained the spirit was that of her mother, who was simply awaiting her arrival.

There are reports of many other ghosts here, including a regiment of Civil War soldiers, a White Lady, a particularly angry abbot, and a coven of witches who were reputed to have been hanged. However, no specific details were available.

C

CANNOCK

An Amorous Apparition

The Swinging Sixties cast off the old taboos and ushered in a time when the voice of a younger generation could be heard.

At the home of the Dyke family, one spectre took this message of 'free love' a little too far, much to the displeasure of Florence Dyke and her daughters. The ghost had taken to climbing into bed with the youngest daughter, Denise, who was just seventeen. He was described as in his thirties and having black, greasy hair, and this was not the first time he had pestered the family, for both of Denise's elder sisters had also had an unwelcome encounter.

Unusually the ghost had only appeared to each of the girls when they were seventeen. He had not been as bold with the elder two, content to stand by their bed. However it seemed the passing of time meant he became bolder. So bold, in fact, that Mrs Dyke took her family out of the house while the local vicar performed an exorcism. Nothing more was recorded, so it is fairly safe to assume the ceremony was successful.

Bootsie

In February 1979 a police officer was patrolling Market Place. Shortly after midnight he was passing the Boots store when movement was seen within. Unknown to the officer, there had been a recent report of a figure at an upstairs window. At no time had the burglar alarms been set off, however, and following a thorough search nothing had been disturbed and no signs of unauthorised entry could be found.

Within the shopping area the story of the ghost – who has become known as Bootsie, after the chain – is well-known. It is said to be a local butcher, who had his shop here and who died in tragic circumstances, although there is no explanation of how he died or why he should be haunting the area around his former workplace.

Lucy

What is now the Longford Farm House was known as the Longford Hotel in May 1998, when news of its resident ghost hit the local headlines. Entering Cannock from the west, you can see this large building on the left-hand side of the famous trunk road. It has offered accommodation for many years under one name or another.

The general manager of the hotel, Tracey Reid, reported that staff and customers were somewhat concerned by the presence of the ghost, who had been nicknamed Lucy. On the first floor, staff were reluctant to be alone, as there had been several instances of bar stools being moved around the room when the place was empty. Several customers had asked to be sat at a different table, for they had felt ill-at-ease when seated at the table nearest the staircase. These were not just reported after dark – problems were equally likely to occur during the daytime.

This was not a recent problem. There are records of unexplained activity ever since 1926. Indeed, when the reports hit the newspapers, one former resident came forward to describe her experiences twenty years before. Ann Gough, who by 1998 was living at Hednesford, had lived here for six months. Her bedroom was located at the end of a corridor with just one way in or out. Several times she heard footsteps approaching along the wooden floor to stop immediately outside her door. When the door was opened, there was nobody to be seen – and yet there had been no sound of anyone walking away again. Understandably Ann was terrified and could not wait to move out.

CANNOCK CHASE

Beaudesert Hall

This home was built by the Paget family who made their name in the sixteenth century and also owned Sinai House. By 1936 the estate had been broken up and sold off. With the house repairs beyond the purse of the owners, Beaudesert Hall was demolished.

One of the later owners was William Henry Bayley, Marquess of Anglesey, Earl of Uxbridge, Lord Lieutenant of Ireland. A politician and military campaigner, he is best remembered for the Battle of Waterloo, fought on Sunday 18 June 1815. Bayley led the charge of the heavy cavalry against d'Erlon's column. His military career was curtailed by two factors – his liaison with Lady Charlotte, the wife of Henry Wellesley (himself the brother of the Duke of Wellington), and the injury he received from one of the final cannon shots of the day, which resulted in the amputation of his right leg.

In the days after the Second World War there were reports that the former owner of the house had returned. It seems several witnesses reported the man, identifiable by his missing limb, riding near the ruins of his former home.

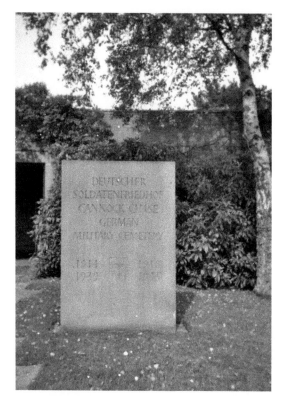

Memorial at the German Military
Cemetery, Cannock.

German Military Cemetery

In 1959 an agreement was reached with the German and Austrian governments
to gather up all the scattered remains of German and Austrian nationals and
bring them to a central site. By June 1967 the inauguration and dedication of this
cemetery on Cannock Chase had been finalised, and some 5,000 graves are now
found here.

During the period when the graves were being moved here, Mr Enoch Walklate
and his wife were driving home after dark. As the headlights of their car illuminated
the road in front they were amazed to see a parachutist, complete with jackboots,
hanging from the lines of his parachute.

This was but one of several very similar reports of ghostly enemy forces dropping
in many years after the Second World War had ended.

Hangman's Oak

This dead tree was an eerie sight for passers-by, even more so for those who knew
the story of Humphrey Haycocke.

For years Haycocke managed to evade the clutches of the Sheriff of Stafford,
who knew he was the main reason deer were disappearing from around Cannock

Chase. One day the sheriff caught him red-handed, but the thief managed to climb a tree and evade capture once again.

The next day, Humphrey Haycocke was seen again. Still in the same tree, Haycocke was dead. He had been hanged by his own scarf as he climbed down the tree.

CHARTLEY

Chartley Moss
A peat bog covering over a hundred acres caused many problems here. A 10-foot-deep layer of peat floated on an unseen lake of water, which had a depth of up to 40 feet. Clearly this would have been a very dangerous trap for unwary travellers.

Legends of the lost souls here abound, while those who have survived the ordeal claimed to have lost swords, dogs, horses, and even whole carts. Whether the ghosts of Chartley Moss were lost beneath the layer of peat is unclear, but there have been sightings of a huntsman riding here, accompanied by an eerily silent pack of hounds.

CHECKLEY

Mrs Hutchinson's Legacy
In 1878 the Revd William Hutchinson passed away. Thereafter Mrs Hutchinson was known for her stern countenance. She ruled the village with a rod of iron, ensuring that few would dare to cross her.

Although she served the Church in no official capacity, she would often visit families who failed to show up for Sunday morning worship, and woe betide anyone who could not give a good reason. There are those still alive who can remember their grandmothers telling them of how Mrs Hutchinson particularly despised two young ladies. Seemingly immune to her venomous tongue, the ladies continued to ride through the churchyard, even though they were well aware it vexed the widow greatly.

Following her death in 1878, reports of Mrs Hutchinson walking the old rectory where she had once lived began to surface. Wearing her old black dress and accompanied by her dog, she was heard knocking on doors and calling out the names of people.

When Ralph Phillips was appointed the new Reverend shortly after the Second World War, he threw a house-warming and invited a few acquaintances to the rectory. Late that evening, when everyone else had retired, one guest noticed that no clock had been left in his room and so went downstairs to retrieve the watch he had left in his overcoat pocket. On the stairs he met an old lady in black with

The Old Rectory at Checkley.

a walking stick, who scowled at him quite disapprovingly. He wished her a polite 'goodnight' but received no response. The next morning at breakfast he looked for the old woman but could not see her. When he made enquiries and described her he was informed he had encountered the wife of a former Reverend; Mrs Hutchinson had clearly invited herself to the house-warming!

Shortly before this, the headmistress of the nearby Hutchinson Memorial School – named after William Hutchinson, who was the major benefactor – had had a similar experience, although in broad daylight. She saw a figure matching the descriptions of Mrs Hutchinson crossing the school grounds. Thinking the woman was visiting the housekeeper, she paid no heed until later, when she had a chance to speak with her employee. The housekeeper insisted she had received no guests of late and the episode remained a puzzle for several days.

During a routine visit to the rectory, the headmistress's eye was caught by a portrait hanging on the wall. The headmistress recognised the individual as the

woman she had seen crossing the school grounds a few days earlier. She learned that she was the latest to witness the long-dead Mrs Hutchinson on one of her ghostly walks.

Today the rectory is a new building and the school itself is much changed. No reports of the Widow Hutchinson have been recorded for many years, so perhaps she has at last found peace.

CHESLYN HAY

The Doctor
A resident of a house built towards the end of the Victorian era told a story that has surfaced several times both before and during their time there. The building has a sizable basement and attic, and so could reasonably be described as having four storeys.

When the present owners moved in almost forty years ago they were only the fourth or fifth owners of the property. At that time the premises had been divided in half to produce two reasonably sized flats, one of which was occupied by the young couple until the rest of the property could be refurbished, which would take some time.

When sleeping in a room towards the rear of the property, the lady of the house awoke. The first rays of light before dawn were sufficient to show a figure framed in a nearby open doorway. The silhouette was sharp – clearly the image of a man who was close to 6 feet in height, with the addition of a top hat making him seem even taller. Although his face was in shadow and featureless, she could see he wore a short cape around his shoulders and carried a bag of the Gladstone style, possibly a doctor's bag. Shortly afterwards, the figure turned and walked into the next room via the connecting doorway. The following night the woman was awoken a second time, this time by a figure in white leaning over the fireplace in the bedroom. To the couple's best knowledge, this was the only time this second figure had been witnessed by anyone.

Sometime afterwards they were discussing the experience with a neighbour who often babysat for the couple. She said she had always felt uneasy in the house, even though she knew it well and had lived next door for many years. On many occasions the hair on the back of her neck had risen for no apparent reason. This uneasy feeling of an inexplicable presence has been reported by other visitors to the house. Like many apparitions, this one appears curious when strangers are around.

Upstairs at the front of the house is another of the dark figure's favourite spots. A guest, who had no prior knowledge of the ghost, was staying in this room when he reported seeing a man in a top hat standing in the doorway. A daughter of the family had had this as her bedroom, during which time she distinctly heard the 'rat-a-tat-tat'

knocking on the door, although when she opened it there was nobody there. Later the girl was in her bed when she felt the mattress sink under the weight of someone sitting down to join her, even though she could see she was alone in the room.

While upstairs the wife has taken to turning on the radio as she goes about her business. The problem is not upstairs but down, where two loose tiles on the mosaic floor move when someone walks over them. This in itself is hardly a problem, except that they rattle when she is upstairs and nobody else is in the house. The sound of the radio only masks the phenomenon.

During the last forty years the family have tried to find an explanation for these events, but have drawn a blank each time. They have always been under the impression the mystery figure was a restless soul, perhaps a general practitioner still paying house calls to a former patient. Investigations into the possible identity of the doctor and his patient continue.

Perhaps the best clue they have is the timing of all these reports. Almost without exception they all occur in November and December. Could it be the doctor was paying regular visits to a sick or elderly patient at around this time of year?

The Police Station

A quick story from the area of Cheslyn Hay where the war memorial stands. A prominent landmark, it is located where the road forks and either side is a one-way system. At the apex of the fork in the road stands a pharmacy. Once upon a time this building housed the local constabulary. Neither profession is given to fanciful ideas or superstition.

Thus it is difficult to understand how, on the upstairs landing of this building, the smell of freshly toasted bread has been reported on numerous occasions, when no toaster has been used and never at the hour for breakfast.

CHURCH EATON

Shropshire Union Canal

Eyewitness reports are vague, however all seem to point to the area around the hamlet of Little Onn. For over two centuries the early highway has wound its way through the Staffordshire countryside. In the height of summer it probably sees as much traffic today as it has ever done.

The interest in canals has seen a boom in the waterways as a leisure industry. Sightings are of a United States Air Force pilot wearing the uniform from around the time of the Second World War. He does not speak, and neither does he seem aware of anyone or anything around him.

Traditionally he is held to be the ghost of a pilot who crashed during the last world war. However the only record of a crash involving our transatlantic allies

occurred on the afternoon of 4 July 1944, when Captain John Pershing Perrin was making his maiden and what would prove to be his final flight in a P-51 Mustang. Belching smoke and flame, he stayed with the aircraft to bring it down in a wheat field and avoided the great loss of life that would have ensued had he bailed out and risked an impact with the houses, shops and schools below.

However, this event took place 15 miles to the north-west, near the USAF base at Creswell. Captain Perrin was not based there; he was travelling in a brand-new aircraft from Preston in Lancashire to Steeple Morden in Cambridgeshire. If the ghost is Captain Perrin, we have no idea why he would be so far from the crash site, or why he would be associated with the canal here.

COLTON

John Landon

In March 1782 in this small village north of Rugeley bad news was delivered to the rectory. The vicar's seven-year-old son, John Landon, had been taken seriously ill at the grammar school at Rugeley. His mother and aunt left straight away, and did not arrive back until late that afternoon.

The boy's mother asked the rectory nurse to return to the school that night. She would feel more comfortable knowing her son was receiving care from a trusted and well-respected individual. Furthermore the school would welcome the help and experience. At 8.30 p.m. that evening Eliza Hodgkinson set off to walk to the school, accompanied by William the groom, who lit the way with his lantern.

Their journey took them to the canal bridge, where they met a lady wearing a brown cloak. While they had never seen her before, she knew them, and even called the nurse by name. The woman asked if the vicar would be at home and seemed annoyed when she was told – quite understandably considering the circumstances – that he would not welcome visitors that evening. It was then she looked down and they noticed a coffin-shaped item under her arm, partially hidden by her cloak. Before they had a chance to ask any questions, the woman vanished. The next day they returned to the rectory and asked if the vicar had had any visitors the previous evening. He had not received anyone since the news of his son's illness.

That night John Landon died, exactly twenty-four hours after the mysterious woman was seen near the canal at Rugeley. Eliza was a respected member of the community and her account of the encounter was never questioned. However, the episode did affect her greatly and she was reluctant to discuss the matter for the rest of her life.

E

ECCLESHALL

George and Dragon

During the 1960s Joe Boffey was landlord of this old coaching inn on the route from London to Chester. A veteran of the Second World War, Joe had been a sergeant in the North African Campaign, when he served with the famous 8th Army. After that experience, the prospect of sharing his timber-framed home with a ghost held no fears and he simply shrugged it off as 'one of those things'.

It was said the ghost is that of a murder victim, although no records had been found of the murder. The ghost certainly made its presence known to the landlord and his wife, who heard creaking on the stairs and doors banging for no reason. Once, in the middle of the night, the couple were awoken by a loud and very insistent banging on the front door. Opening the door, they saw no sign of a soul, living or otherwise.

However, the most disturbing discovery awaited them one morning in the middle of a lounge table. There was a time, for those too young to remember, when smoking was allowed in pubs and the ash trays were always metal. Imagine coming down in the morning to find the ash trays crushed together in a mass in the middle of one table.

The Ghost Mile

On a stretch of road that seems to be appreciably less than its 1,760 yards, many have seen what appears to be the same figure, a man in a costume apparently dating from the Tudor period. He seems to glide, rather than walk, across the road and has been blamed for a number of accidents here.

One driver braked sharply when the figure suddenly appeared in front of him. However, he did not have sufficient time to avoid hitting him and was convinced he had run the man over. Shaken, he stepped out of his car to check. He was dumbfounded to find no blood, no body, and no evidence of an impact.

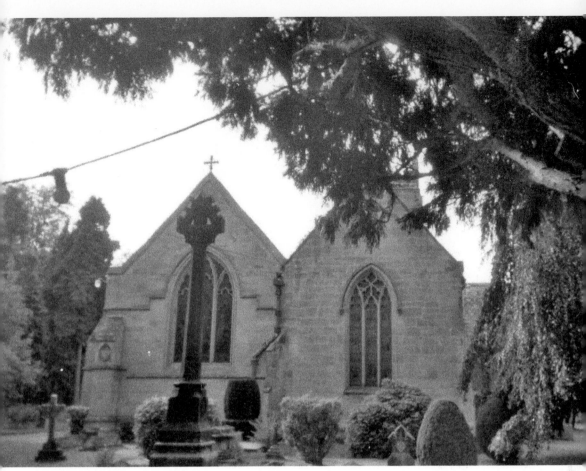

St Peter's church at Elford.

ELFORD

The Revd Francis Paget
The Revd Paget served his community from 1835 to 1882. He was held in high esteem by the villagers and was known for his forthright and very Victorian beliefs. In one of his sermons, which have been collected and published, he called upon the labourers of the land to partake of leisure activities, in particular the local cricket club. But he warned they should pay close attention to the rules of the cricket club, suggesting these were applicable to daily life.

In 1877 Paget wrote a letter describing an event that had taken place in the rectory several years earlier. It was the early winter's afternoon, and the sun had almost burned off the last remnant of the foggy morning. He left his study and walked along the passage towards the living room at the end, where, illuminated

by the light coming through the open door, there was a much denser mist than had been seen outside all day.

In his letter Paget described how the mist swelled, as if fuelled by a jet of steam from below, until it formed a conical shape tapering to a point at the top. Approaching closer to investigate, the mist began to assume a human shape from the head down. At first the features were indistinct, although the body began to show a full-length cloak reaching down to the stone floor. He even noted how the wooden panels from the room beyond were visible through the lower part of the mist.

He stood and watched, more intrigued than transfixed, still believing it a trick of the light. Detail began to appear and the familiar face of a friend was recognised. He goes to great pains to explain in his letter how the appearance was never in any way frightening; indeed the sight of the familiar face brought him a feeling of peace and serenity he would never forget. Suddenly the mist cleared and he was alone once more.

The friend in the mist had not been on the Reverend's mind that day, nor had they corresponded for several weeks. However, the man was very much in Paget's thoughts the next day when the Reverend received news that the friend had died. Furthermore, the time of his death coincided with the exact moment of his appearance from the mist at the rectory. The Reverend explained that he felt his friend, whom he did not name, had paused to say goodbye on his way to the next life.

Finally the letter makes the point that for the next five years, while he was resident at the rectory, he had passed over the spot where the mist had formed many times. Every time he did, he remembered his friend with affection and pleasure, and not a hint of sadness.

ENVILLE

A Hooded Man

200 yards uphill from the church of St Mary is a bend in the A458 road. Negotiating this bend today is difficult enough with modern tyres and twenty-first-century road surfaces; on a dark and rainy evening in 1967 it meant dropping down through the gears and greatly reducing speed.

Mr and Mrs Tromans were enjoying their evening, despite the inclement weather. Travelling west along the road to Enville in their 1964 black-and-white Triumph Herald, they approached the summit and its bend, slowing to approximately 10 mph. As the car's headlights swung slowly around, the beams picked out a dark figure crossing the road from the opposite side. Both husband and wife saw the same thing – a male figure at least 6 feet in height striding with a decided spring in

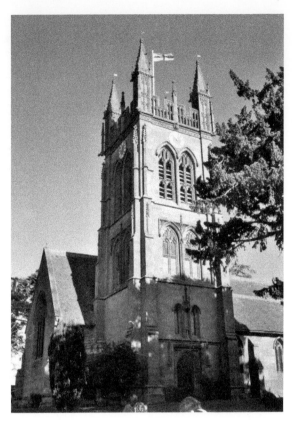

St Mary's church, Enville.

his step across the road, apparently oblivious to the danger of the approaching car. Later, both agreed that what they saw seemed not quite solid, even less so as the figure vanished directly in front of them. As the hairs rose on his neck and a chill shivered down his spine, Mr Tromans instinctively depressed the accelerator and the young married couple soon left their experience far behind them.

Since that time, Mr Tromans has negotiated the same stretch of road in a number of different vehicles, both at night and during the day. Not once has he seen anything, nor has he ever heard of anyone else having witnessed anything similar.

ETRURIA

Etruria Hall
The funding for Etruria Hall, a Georgian property designed and built by Joseph Pickford from 1768, came from the owner, Josiah Wedgwood, who lived here for the rest of his life. Indeed, he died here in 1795. It remained in the family until 1840 when, owing to financial problems, it was sold by Francis Wedgwood.

It housed a school for young ladies and gentlemen, and later became the offices of Shefton Iron & Steel and finally the British Steel Corporation. Little of significance to our story is reported until 1986, when the building became the headquarters of the National Garden Exhibition Centre. This is not surprising, for refurbishment and rebuilding are often the catalyst for paranormal activity, indeed even minor changes of fixtures and fittings have been known to upset these uninvited guests.

Not long after they had arrived, centre director John Hyde and his secretary Pauline Brookes heard rumours of a tunnel under the hall, a tunnel said to have provided access for original owner Josiah Wedgwood to the neighbouring works. This is not unusual; there are many stories of tunnels beneath old buildings. If only half were true, this would see our island honeycombed by tunnels.

Twentieth-century health and safety concerns meant Mr Hyde had to bring in inspectors, who made a thorough search of the cellars but were unable to find any evidence of a tunnel. The story was dismissed as a hoax. Yet those who had worked in the building for many years insisted they had seen evidence of the opening. As one young lady pointed out: if ghosts existed, why not ghostly tunnels?

Both Mr Hyde and Mrs Brookes noted how certain parts of the old hall had a distinctly unnerving atmosphere. Furthermore, several people had noted inexplicable clanging and banging noises since the work had started. However, this was not during working hours; indeed, the noise of the rebuilding may have been masking unexplained ghostly sounds during the daytime.

An electrician had a particularly troubling experience. Working at one end of a room known to have given the shivers to several individuals at various times, his hair quite literally stood on end. Of course, the obvious answer is that static electricity was the cause – yet at the time he was not touching a circuit and was earthed.

At no time has anyone seen anything, although a visitor to the centre maintained they could certainly detect the presence of 'Jos' (i.e. Wedgwood senior). However, it was not recorded how this person identified the original owner of the property.

Rose & Crown
In October 1969 the world was in the grip of Moon-fever. The second manned landing, *Apollo 12*, was just days away. Back in the Potteries, a local pub was home to an equally alien atmosphere.

Landlord Clifford Manning had been there for two years with his wife, his son Richard (who was then fourteen years old) and his mother Mrs May Harris. Troubles began fairly soon after they moved in. First the pegs from the beer barrels started to go missing or were moved from one place to another, despite there being nobody around.

Worse was to follow. A drip tray from the bar was left in the cellar overnight – Mr Manning clearly remembered he had left it sitting on a bench there. The following

morning the drip tray was no longer there. Somehow the drip tray had found its way into a cupboard, where it was eventually discovered by Mrs Manning. The landlord had often experienced the hairs on the back of his neck bristling when working in the cellar.

One person had witnessed the ghost, not in the cellar but upstairs in a bedroom. Mrs May Harris, the mother of the landlord, was sitting up in bed reading when she became aware of a figure standing by the bed. Looking up, she saw a slim figure dressed in white robes similar to those worn by a nun, although the face of the individual was not discernible, meaning its gender was unclear. As she watched, the figure vanished from view, although at no time did Mrs Harris feel afraid.

No explanation for these events was given in 1969. Enquiries in 2010 found nothing had been reported in the memory of anyone connected to the establishment on either side of the bar.

White Rabbit

On Sunday 4 August 1833, one Mr Davis was enjoying a stroll through Crabtree Field when his eye caught something in a ditch. He discovered the body of a boy, who have evidently been strangled by the cord still tied around his young neck.

It was later identified as the body of John Holdcroft, a boy of just nine years who had been employed at the Waterloo Road factory of Joseph Hawley. John had left the shop where he worked at 6 p.m. on the Saturday evening, having pocketed his wages, one shilling and sixpence. This was the last time he was ever seen alive, other than by the murderer. John and Charles Shaw had both been paid by the manager Jason Turner.

At the inquest on the Monday, held at the Etruria Inn, coroner Mr Harding heard how both boys had left the factory together with money in their pockets. Yet when his body was found his pockets were empty and the money – which he faithfully took home to his mother each week – had gone. Thus a motive had been found and the finger of suspicion pointed to his colleague, fourteen-year-old Charles Shaw.

It was decided to adjourn the hearing for two days in order to bring the accused before Mr Harding. When Shaw was brought before the court on Wednesday, his defence were found to be unpersuasive. In March 1834, a jury found him guilty of 'wilful murder'.

The statutory punishment for murder was death. However, because of Shaw's young age, his sentence was commuted to transportation for life and he lived out the rest of his days in an Australian penal colony.

Back in Staffordshire, there is a small copse in Crabtree Field. Almost from the very day of the murder there have been innumerable reports of the voice of a terrified young boy emanating from deep in the undergrowth.

There is also the little matter of the white rabbit that crosses the path here before disappearing, sometimes accompanied by a faint cry for help. For years the very mention of this seemingly innocent creature sent a chill through the locals, for it was thought to be a portent of death.

The answer to the problem of this white rabbit was thought to rid the field of the rabbit. When a man volunteered to perform the task, spirits were lifted. However, when the fearless hunter launched himself upon the accursed lagomorph, he succeeded only in dislocating his shoulder. This injury served only to fuel the belief this rabbit was very bad news indeed.

F

FAZELEY

The Soldier

In 1972, Alan was driving home to Birmingham. An enjoyable night out in Tamworth had not seen a drop of alcohol pass his lips and thus he was quite sober as he travelled the A4091 almost directly south.

Passing through the village of Fazeley, he crossed the rise that marks the line of the Birmingham & Fazeley Canal. From here the lights marking civilization fell away and the vehicle was swallowed by the darkness of a wet and windy spring night. It was almost midnight. Suddenly Alan was aware of a man walking ahead of him at the side of the road, seemingly heading in the same direction. Alan's first instinct was to stop to give the man a lift, but something made him look again.

Lit by the headlights was a tall man wearing something on his head resembling a balaclava – perhaps a scarf pulled up over his face? A large collar topped a heavy coat, below which he could see the gaiters and boots of a soldier. Since he was a man who had served his country, Alan felt he deserved a lift and pulled over.

He was within half a car's length of the soldier when, as if he had touched a reflection in a pool of water, the image shimmered and scattered into the trees and bushes lining the road.

FOUR CROSSES

The Four Crosses Inn

For some four centuries on the A5 Watling Street west of Cannock is a former drover's inn. A natural pond in the road here allowed the cattle to take a drink on the way to market; the drovers preferred to take advantage of the refreshment within.

On visiting the place, the author was met by a gentleman who has known the place for many years, as both a customer and member of staff. Psychic investigators

The canal bridge at Fazeley from above...

... and from below.

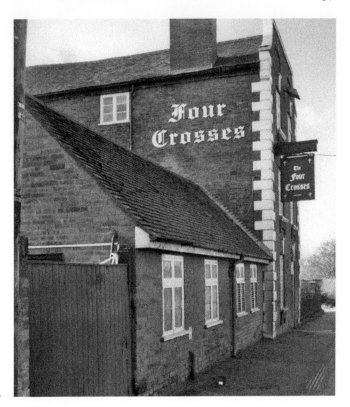

The Four Crosses Inn.

were interested in reports of three characters: a young boy named Scotty; Charlie, a habitual drunk from the nineteenth century; and an unnamed soldier. None were known to any of the customers or staff.

However, two other characters reported by the team were known to customers and staff alike. First they told of how the original front door, leading out to the very busy trunk road, is still used by the ghost of a careless customer who had wandered out and been hit by a passing lorry. This doorway is still quite evident from outside, yet inside the unsafe access has been plastered over. Long-time regulars and staff remembered the incident well, however they questioned the team's findings, for the vehicle was not a lorry but a BMW, and there was no way he could be walking through the sealed door for he was very much alive and drinking in the pub!

A second story was of more interest. Investigators identified a woman's perfume and reported a strong sense of great sadness, the weight of the troubles of the world on this spirit's shoulders.

In the bar hangs a black and white photograph of regulars from the early 1950s. One person stands out as the only woman among the twenty or so men. Retrospectively it is all too easy to think she looks very unhappy, yet she probably had good reason to feel so. A married woman, her long-term affair with a manager

of a nearby colliery was hardly a closely guarded secret. It is known friends had warned her not to continue with the liaison, as he was described as a 'very nasty man'.

Later the body of this attractive blonde was found one winter's night in her own home; she had been strangled. With no sign of a forced entry, the murderer was probably known to her, and with her husband having an alibi attention quickly turned to the lover. He insisted he had been at work that time, indeed witnesses had seen him descend into the shaft with his colleagues and return with them at the end of the shift. However, police suspected he had left work and walked across the fields to visit her, especially as not one of the men on the shift could recall seeing him during that time. This was circumstantial evidence at best, so it should have come as no surprise when his defence counsel ripped the prosecution's case to shreds and he was acquitted.

Those who knew the man remained convinced of his guilt. Hence it was seen as poetic justice when, just three months after walking from court a free man, he was cycling to work when he died beneath the wheels of a Walsall bus.

FRADLEY

Australian Pilots
RAF Lichfield, as it is correctly called, opened in 1940 and was initially a training base. During the earliest months of the base, newly fledged pilots were not permitted to go on bombing raids but were sent with a propaganda payload. Leaflets containing messages designed to raise French spirits were dropped across northern France.

Later they were permitted to take the large Wellingtons across the North Sea on bombing raids against Germany. Locals could not fail to be aware of these massive craft taking off and returning to the base. At over 64 feet in length, with a wingspan of 86 feet and a top speed of 235 mph, fully laden they could weigh as much as 13 tons at take-off.

One night a resident was awoken by a Wellington returning from a bombing raid. Nothing unusual in this – the aircraft were so low over the roofs of these homes that the man of the house had remarked on more than one occasion of how they would 'take the bloody roof off one night, gal'. But on this particular night the man woke to a frightful noise. The spluttering, straining engines of a bomber were clearly struggling to keep the massive craft airborne. Dragging his wife from their bed and virtually throwing the two of them down the stairs, the man took refuge under the kitchen table – not quite as futile as it sounds, as furniture was solidly built in those days. To their disbelief, the noise levels peaked and then ebbed away as the aircraft landed.

Next morning the man woke before his wife. Off he toddled, bleary-eyed and barely awake, to answer a call of nature. Shortly afterwards he returned to their bedroom and woke his wife. Taking her to the window, he threw open the curtains. Instead of the wooden privy at the bottom of the garden there was a gap in the fence and, beyond, fragments of wood in the field beyond. The pilot may have missed the house, but the undercarriage had ripped the tiny wooden shed from their garden and deposited the barely recognisable fragments in the neighbouring field.

Another accident had tragic consequences. Taking off from the airfield one evening it was soon realised an engine was on fire. Abandoning the mission, the four airmen, thought to be Australians, turned for home. The tight turn and lack of manoeuvrability made handling the craft very difficult and, as they turned, it stalled. On impact the flames engulfed the fully fuelled plane killing the crew. As the ground crew neared the crash site the 500-lb bomb they were carrying exploded, injuring four of them.

Since that time there have been a number of reports of men dressed as pilots being seen wandering around beside the busy A38 trunk road.

G

GREAT HAYWOOD

Coach and Horses
For a few months in 1976 there were a number of reports of a man in the road outside the Coach and Horses. Motorists had to swerve to avoid this character, who was not crossing the road but wandering haphazardly.

Former barman Colin Morrissey ended up in a nearby ditch to avoid running the man down, and thankfully both driver and vehicle were pulled out without a mark. On St George's Day in 1976, eighteen-year-old customer Jackie Buxton was visibly shaken when she not only saw the man but was convinced she had knocked him down.

A man answering the same description was seen within the pub too. Explanations have never been found for the gas taps to the beer lines being turned off in the cellar. Meanwhile in the bar, witnesses watched in amazement as pot plants moved of their own volition.

Locals point to former landlord Reggie Smith as the most likely culprit. Although nobody has ever seen his reputed ghost, he is said to have hanged himself in the loft of the pub.

Pedestrian
What had become a regular commute along the A51 from Stone to Birmingham was interrupted one autumnal morning.

The normal morning rush-hour traffic was confined to the motorway, hence the choice of a slightly slower road, but it was one that should have held few surprises. What the driver did not expect was what he faced just half a mile before Great Haywood, where the road runs alongside the Trent & Mersey Canal. On a day where visibility was excellent and road conditions were good, he was forced to take emergency action when a pedestrian walked out into the road almost in front of him.

He slammed his foot hard down on the brake. The car skidded and only good driving and a fair slice of luck meant it did not end up in the drainage ditch at the side of the road, nor collide with another vehicle. The driver leapt out of the car and looked around. While mere seconds had passed, there was nobody to be seen and no way the person could have left the scene so quickly.

Shaken but otherwise uninjured, and with his car undamaged, he continued on his way and forgot about the incident. But a year later, almost to the day, he was travelling along the same road in almost the same spot when he saw exactly the same thing and again put his foot hard on the brake. However, this time he realised immediately what he had seen.

As is common in the early morning in autumn, a mist had risen from the waters of the canal. A faint breeze had disturbed the thin wisps and brought them up to the road when the sun's rays had illuminated them – making it seem as if someone was there. Mystery solved.

GREAT WYRLEY

The Wheatsheaf
Many pubs are the scene of unexplained phenomena. There are those who claim this is the result of the *other* kind of spirits. However, the Wheatsheaf does not support this theory, for nothing is known to have been reported by customers, only management and staff, who we must assume did not have their judgement impaired by alcohol.

This pub has been known as the Wheatsheaf for at least two centuries, and only the oldest part of the building, the central area, has seen any activity. In the roof space, electrical repairs were being carried out. The engineers, who had not heard of any paranormal activity and afterwards admitted they were sceptical of the existence of ghosts, reported they had felt an unnatural chill and were very uneasy throughout.

Outside of normal licensing hours, both at night and before the doors are open each morning, unexplained shadows have been seen around the public area. Awoken by sounds coming from the bar below in the early hours, the management took their large Rottweiler with them to investigate the bumps and bangs of what they presumed was an intruder. Descending the staircase, they entered the large room and flipped the switches, flooding the place with light. Their dog, having been straining to get away as they came down, was now cowering in the centre of the room, growling at something they could not see.

However, the most active part of the building is the cellar. Items were found to be moved, a nearby presence was felt, and the taps from the barrels were turned off without warning, culminating in one member of staff feeling a distinct tap on the

The Wheatsheaf, Great Wyrley.

shoulder. On turning, he found he was alone. Once again, no member of the public was in the building, just the licensees and the staff.

Some years ago, thought to be during the 1960s and '70s, successive landlords would tell stories of how they were disturbed in the early hours of the morning. Footsteps could be heard coming from inside a former function room, long empty. At times these footsteps would be accompanied by jazz music. Chairs were heard being dragged across a wooden floor, and the electrical equipment was notoriously unreliable.

Maybe the answer lies in the man seen dressed in an old RAF uniform?

H

HANBURY

Fauld Crater

On the morning of Monday 27 November 1944 at 11.11, seismographs all over Europe picked up a massive eruption somewhere in the north-west of the continent. However, this was no volcano. This was the loudest explosion of the Second World War save for the atomic bombs dropped on Nagasaki and Hiroshima the following year.

At the time little was known of the event – understandably so, as the nation was at war and bad news was quickly censored. These disused gypsum mines were storing munitions in two caverns some 90 feet below ground. Thirty years after the event, it was revealed that bombs had been taken out of storage and primed for use. When plans changed they were returned to storage with those detonators still intact. An initial detonation set off all 3,670 tons in one huge explosion.

As far away as Coventry, Daventry and Weston-super-Mare, this gigantic explosion was heard. It left a crater 250 yards in diameter and 300 feet deep. The displaced soil and pieces of the local livestock rained down over a wide area. The larger pieces, weighing up to a ton, destroyed two farms and the local pub, the Cock Inn, while not a building in Hanbury remained undamaged. A nearby dam was destroyed, releasing all six million gallons of water from the reservoir and creating a 15-foot-thick mudslide to pour into the local plaster works and kill all within. Finer soil was thrown an incredible 11 miles into the air. It drifted down to shroud the area in a choking grey blanket, 4 inches thick. Civilians, RAF personnel and Italian POW casualties included seventy-eight or eighty-one fatalities, depending on the source. At least eighteen bodies were never recovered.

Fire services from as far afield as Stoke-on-Trent, Burton-on-Trent and Lichfield attended and worked alongside RAF personnel to rescue any survivors. They discovered an elderly couple that afternoon, four hours after the explosion, still seated at their dining table, with plaster from the ceiling coating their food. They

stared at one another in a state of shock, unable to say a word, until rescuers managed to assure them there would be no further explosions.

In a field they found a cow. The poor animal was at least twice its normal size; it had been inflated by the blast of air. They shot it immediately to put it out of its misery, only to find it remained standing, as it had been wedged in the ground by the force of the blast.

The explosion happened in one of two caverns underground. The second and very much larger store was protected by a narrow tunnel and did not explode. If both stores had gone up, the damage would have been immeasurably worse and no amount of censorship would have been able to conceal the truth. The remaining cavern was used as a storage facility until 1958.

Today the crater is still there, off-limits to all as it remains Ministry of Defence property. Overgrown, it still manages to impart a very real feeling of desolation. Visitors to the area, even those with no notion of the wartime events, have described an overwhelming feeling of grief. Furthermore, reports continue to come in of an eerie singing in the air, and many have heard the most pitiful sobs emanating from beneath the ground.

HARRISEAHEAD

Jenny Hall
Daniel Shubotham, a founder of Primitive Methodism, lived in this area during the first half of the nineteenth century. Jenny Hall was a contented and much-admired member of the community. Happily married and hard-working, she was a student of Shubotham.

It was not difficult to see something was wrong with Jenny. One year her demeanour changed completely. Gone was the carefree woman with a smile that would brighten any day. Her initial loss of confidence rapidly spiralled into the darkest despair. Very soon the mild-mannered Jenny was shouting and swearing – violent outbursts of such ferocity it was unwise to be within earshot. Indeed, her poor husband, who steadfastly refused to abandon the woman he loved, barely escaped with his life when she flew into one of her wild rages.

She was taken to the poorhouse and strapped to the bed for her own protection as much as for others. Daniel Shubotham was summoned, and he wrote to his fellow Primitive Methodists William Clowes, William Summerford, and T. Cotton. Together they prayed for Jenny at Shubotham's home, however the attempt was a failure and further steps became necessary.

A period of fasting and prayer ensued and, when they were confident the property was suitably prepared, they sent for Jenny Hall to be brought to them. Unfortunately she escaped on the journey and was not found again until the

following morning, when she was seen wandering the fields around Harriseahead. This time she was brought before the four preachers and together the group prayed for the deliverance of the possessed woman.

As they prayed the woman, still held by her captors, became more and more aggressive – thrashing about as if being torn apart from within. Her face became an evil shade of black, a dreadful inhuman rattle issued from her throat, and she foamed at the mouth. Still the four prayed more earnestly than ever. When they were almost completely exhausted – just as they thought they could go on no more – Jenny shouted the name of the Lord and was finally free of her demon.

Jenny lived for at least another twenty years in the area around Harriseahead, unlike the four men, who travelled extensively preaching their version of the gospel. Every time she met one of the preachers she would make sure she always thanked them for their efforts in freeing her and making her the same Jenny Hall everyone had known before.

HEDNESFORD

Cross Keys Inn
Built in 1746, the Cross Keys Inn marks the part of Hednesford that was then the centre of the town. On the wall of the pub is the date it was built and the initials TWC, which may be the initials of an early landlord but seems more likely to be advertising Taylors Waggon Company, a major haulier in the days of the coaching inn. The latter seems most likely as the pub stands on an ancient packhorse route known as Blake Street. During the eighteenth century it is recorded as a staging post for waggons and stagecoaches.

Later the pub was the local of Dr William Palmer, the notorious Rugeley Poisoner. Palmer's Lounge at the Cross Keys was named after him. Palmer was the first person in the country to be tried for murder by the poison strychnine.

One fateful day, Palmer and his acquaintance John Parsons Cook spent a day at the races at Shrewsbury. Cook won a substantial amount of money and he and Palmer enjoyed a celebratory meal before returning home to Rugeley. The next day Palmer invited Cook to dine with him, whereupon Cook became violently ill and died two days later.

The post-mortem on John Parsons Cook found no traces of poison, most likely the result of incompetence, and Palmer's resulting conviction was purely circumstantial. He claimed the poison found in his possession was used in his experiments, yet was convicted on the finding that Cook died from symptoms that could have been caused by strychnine.

Known to be heavily in debt, the so-called Prince of Poisoners was certainly guilty of attempted bribery, fraud and forgery, and clearly he had done everything

possible to tamper with the evidence against him. His conviction for the murder of Parsons was the only crime of which he was found guilty, although a coroner's enquiry pointed to him being responsible for the deaths of his wife Ann and brother Walter. Locally he was also held to have killed four of his five children, his mother-in-law, and at least another half-dozen.

It has been said that a sailor, a victim of the Rugeley Poisoner, haunts the former local of his murderer. This story seems to be purely anecdotal, for even those who have used the pub as their local for decades have neither seen nor heard of anyone seeing a sailor. One person claimed the story came from a psychic who visited the pub, so presumably the victim identified his murder to them, for there is nothing recorded concerning a sailor.

What *has* been reported, although not in Palmer's Lounge, was a glass ashtray moving from one end of the bar to the other, untouched by human hands. This happened prior to the current landlord taking over the reins, and he had never encountered anything that could not be explained – save for knocking on internal doors when nobody was there.

HILDERSTONE

Hilderstone Manor

This is a small village, but one with a long and fascinating history. Since its entry in the *Domesday Book*, a number of famous individuals have had connections with Hilderstone. Sir Arthur Sullivan, best known for his collaborations with Sir William Schwenck Gilbert, penned several songs with other lyricists, including H. F. Lyte. Together they wrote 'The Sailor's Grave' in the 1870s, which was dedicated to 'Mrs Bourne of Hilderstone Hall' and became so popular that picture postcards were produced to celebrate it.

Renowned composer Sir Edward Elgar also has a connection to Hilderstone, since he married a local, Caroline Alice Roberts.

There is also a suggestion that Robin Hood may have had some connection with the place. It is generally accepted today that Robin Hood is a composite of a number of characters. Hilderstone was held by Robert Fitzodo (the 'Fitz' being the equivalent of 'Mac' or 'son of'); '-odo' is also recorded as '-heud'. At the beginning of the tales, the hero is referred to as Robin of Loxley, and a Robin of Loxley (the grandson of Hugh Fitzodo) was a sub-tenant in Hilderstone. Furthermore, Robin of Loxley fathered daughters, one of whom married a William Trussell, the family name being the Saxon word for 'red' – so connecting William Trussell to Will Scarlet is irresistible.

It remains to be seen if any of these figures could be responsible for the noises at Hilderstone Hall. Some really unusual sounds have been heard when there has

been nobody around who could be responsible: everything from a cacophony of sound to furniture being dragged across the wooden floor, doors opening and closing, the footsteps of an unseen man, and something that is rarely heard today – the sound of a clock being wound.

Oddly, these sounds were never reported by the first occupants of the house, indeed they insisted they had not experienced anything during their tenure. Furthermore, by the time the first disturbances had been reported there had yet to be a death on the premises and so it is difficult to establish a link between the ghostly noises and the past.

HILTON

Hilton Park Services

Built on the M6 to the south-west of Cannock and opened in 1967, Hilton Park Services incorporate two towers that once gave panoramic views of the region. However, due to fire regulations, the towers were closed and remain so.

It is the northern side that interests us here, for during the building of the service station it is said a man died, although no record of how he died can be found. In 1974 one woman who was working in the cafeteria reported that the dead man was forever opening and closing the large refrigerator. The woman would often be forewarned of his presence by the sound of his 'manly footsteps' approaching along the corridor.

HIMLEY

Gideon Grove

Himley Wood has a number of pathways worn by the feet of hundreds of generations. Our story concerns the delightfully named Gideon Grove, the groom of Stephen Lyttleton of Holbeche House in Kingswinford.

In November 1605, Robert Catesby, Thomas Percy, Ambrose Rockwood, the Winter brothers and Kit and Jack Wright managed to evade their pursuers here for three days. Some may find the date and names familiar and with good reason – for these men were involved in the plot to blow up the Houses of Parliament. Stephen Lyttleton was a known sympathiser and so they headed there, seeking temporary sanctuary.

Seventeenth-century travel was hardly a leisurely journey; it involved crossing miles of open country, woodland and marsh. The journey, along with November's inclement weather, soaked the men's gunpowder, leaving them virtually unarmed should their pursuers, led by Robert Walsh, Sheriff of Worcester, overtake them.

It may sound foolhardy in the extreme, but these were desperate men. Having reached Holbeche, they proceeded to dry their gunpowder in front of an open

fire. The inevitable explosion alerted the sheriff and his men and they stormed the house. Chaos reigned. A couple of small fires were burning, smoke was filling the rooms, and several were injured. One John Grant had been blinded by the explosion. As the two sides fought a confused battle, groom Gideon Grove fled in panic.

In truth, the young groom was very unlikely to have been accused of anything. Had he stayed where he was, he would have lived to tell the tale of the day the Gunpowder Plot conspirators were captured under his nose. However, he feared for his safety and, quite understandably, he fled on horseback in the direction of Wombourne, hotly pursued by the sheriff's men.

Little more than half a mile into the chase, the horse and his terrified young rider plunged into Himley Wood and almost instantly found themselves in a swamp and sinking fast. Close behind were the sheriff's men, who dismounted and gathered around Gideon, who called out and pleaded for their assistance. Their only response was a hail of musket balls, which cut short the man's life.

Doubtless little would have been heard had there not been a witness. Unknown to all, an old charcoal burner had been watching over his smouldering pile and, not daring to move a muscle should he be implicated, he watched in silence. This was not the easiest task to achieve, for the charcoal burner was required to watch over the earth-covered wood pile in case the fire burned too quickly, thus consuming the wood, or too slowly and thus go out. Clearly this boring task would result in the man falling asleep, and so charcoal burners took to sitting upon a stool with legs missing. If sleep did come, he would fall – hence the expression 'to drop off'.

Much later the man did dare to tell and an explanation was found for the mysterious dark rider seen thundering along the bridleways between villages, and the sound of pounding hooves that ceased abruptly at the wood. The ensuing silence was more terrifying than the ghostly sight of a young man's body floating to the surface of the bog.

For four centuries this phantom horseman has terrorised many a passer-by. In 1974 Monica was a passenger on the back of a motorcycle returning from Ditton Priors. It was the early hours of the morning when they came to a halt along the Bromsgrove road, near the Swindon–Trysull crossroads. Even wearing crash helmets and above the noise of the engine, the sound of pounding hooves was unmistakeable and quite deafening. Both were overcome by a feeling of great terror and Monica later described it as like being 'caught in the middle of a great stampede'. Oddly the road shook with the pounding of the invisible hooves, while all around there was an eerie stillness. The next day she recounted the experience at work and for the first time heard the story of Holbeche House and Gideon Grove.

Three years previously, Joe – another who had never known of the area's association with the Gunpowder Plot – was driving home on the well-lit road

between the junction of Common Road and the Brick Bridge public house. It was 13 July and exactly forty minutes before midnight when the street lighting was suddenly extinguished. Such was Joe's surprise that he stopped the car and got out to witness a sight he was never to forget.

He heard it first – the sound of pounding hooves coming towards him. As he looked in the direction of the sound, he saw a horse and rider galloping along some 3 feet above the level of the road. His car headlights illuminated the scene and he clearly saw the rider wearing a cocked hat, a dark blue velvet coat and thigh-length riding boots, seated upon a dappled-grey mount. As the rider and horse passed, Joe noticed the red glow and flickering of flames coming from the direction of Holbeche House. As abruptly as they had vanished, the street lights returned, signalling the disappearance of the rider and the fire. Joe returned to his car and drove home.

Two years later he came across an article relating the events surrounding Holbeche and the Gunpowder Plot. For the first time, he realised the significance of the events he had witnessed.

Holbeche House

A related story was told by a motorcyclist travelling south on the A491 late one night. Approaching the bridge, he slowed. Ahead of him three figures were standing at the side of the road and he was wary of them carelessly stepping out in front of him. They were standing with their backs to Holbeche House and its old grounds.

His caution was justified, for the three strode confidently across the road as he watched. It was then that he noticed their attire – clothing that belonged to an earlier age. However, no sooner had he noticed this than all three had reached the opposite side of the road and disappeared as they walked straight into the bank of sandstone. This outcrop of red sandstone is an effective wall that stretches along the opposite side of the road from Holbeche. It can only be climbed with some difficulty, and there is no way around it for some distance.

Having avoided the men, his attention was taken by a vehicle coming in the opposite direction. The driver of the car wound down the window and exclaimed, 'Christ mate! Did you see that?' before moving rapidly through the gears as he drove away. The young motorcyclist also continued on his journey. Arriving home, he was still visibly affected by the experience and was reluctant to speak of it for some time afterwards.

Was this a flashback to the battle between the sheriff's men and the conspirators behind the Gunpowder Plot?

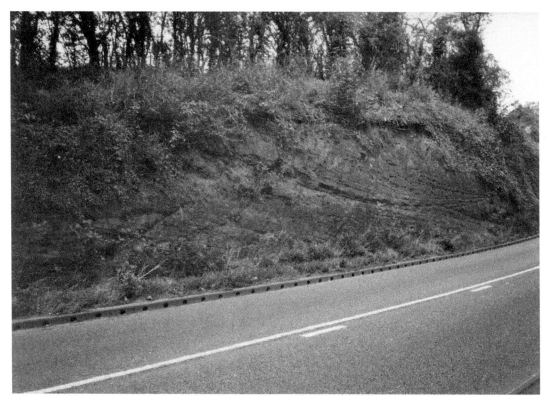

Sandstone cliff face opposite Holbeche House, Himley.

Himley Hall

This eighteenth-century building, which replaced a demolished medieval manor house, became home to the earls of Dudley after the disastrous fire at Dudley Castle. The gardens, the work of Capability Brown, are still open to the public.

Within the hall itself, nothing of note has been reported – unlike the road near the main gate, where several motorists have had to swerve to avoid a woman running across the road on a number of occasions over several years. Descriptions of this woman are quite consistent. She is young, running from the hall at good speed, and always wearing clothing from the Victorian era. Unfortunately there is no event or individual that could offer an explanation.

A sponsored ghost hunt in 1978 organised by a local radio station serving a care centre was well supported. About twenty individuals there all saw an exceptionally tall figure wearing black floating above the wood where Gideon Grove was brutally killed. In another area an icy chill fell as a dark triangle appeared and then took the shape of a man. Later it was discovered that a number of bodies had been found in the wood in the distant past. During the hunt one person had a torch fly

from their hand while another, who had been tightly clutching a palm cross, found the object had disappeared by the end of the hunt.

HOAR CROSS

Hoar Cross Hall

This Victorian country mansion is a rebuild of the earlier home of the Ingram family by Sir Hugo Meynell, the husband of Elizabeth Ingram. Today it has seen a complete upgrade and the Grade II-listed building is among the most exquisite hotels in the county and also incorporates a health spa.

For some years, stories of the ghost of a mournful young girl had filtered out of the hall. Eventually, in 1974, the then-owners Bill and Gwyneth Bickerton-Jones came forward to tell of their experiences. All but one of the family had heard the sound of a child crying, particularly in the upper rooms, which were used as nurseries and occupied by live-in servants. Many had described an unnatural chill when walking along these upper passageways.

At first only mother Gwyneth and her fifteen-year-old daughter Vivienne had seen the girl. She was said to have been approximately nine years of age, and wore a long dress and mob cap. Later the girl was seen by father Bill, too. While in his bed he had watched as the ghostly form of the young girl floated clean across the bed right in front of his eyes.

News of the activity at the hall reached the ears of two employees of the Elliott Lucas factory in Churchbridge. These men, Don Eccleston and Tony Bullivant, were part of a team actively involved in charity work. At the time they were raising funds for new radiographic equipment at Stafford Infirmary. One Saturday evening, on what was Tony's thirty-fourth birthday, the plucky duo took up the challenge of spending a night at Hoar Cross. Both had admitted to being highly sceptical of the existence of anything paranormal prior to their all-night vigil.

Their sponsored sit-in passed without incident until four o'clock on the Sunday morning. Don, who was just then succumbing to sleep, awoke with a start for no apparent reason. He could clearly hear a child sobbing nearby, although Tony never heard any such sound.

They had chosen this particular room as it was in the upper part of the hall. At the end of the nineteenth century it was said a seven-year-old girl had died following a convulsive attack. She would likely have survived had her nanny not been in another part of the house at the time, visiting a manservant.

Since the building took on its role as a hotel and spa there has not been a single recorded instance of anything untoward. Is the young girl's spirit finally at rest?

The Fox at Hopwas.

HOPWAS

The Fox

One of the most popular pubs in the area, the Fox was famous in the 1980s for its gammon dishes – and rightly so, as the author found out on many an evening. However, the history of the place goes back at least 180 years and possibly more.

The first record we have is of three adjoining but separate cottages. They were certainly here in 1830, however it is perfectly possible they were built some time before this. The 1871 census still lists three properties, yet ten years later the 1881 census says they had become a public house. Clearly during the intervening ten years the three properties were knocked into one. The landlady was given as Elizabeth Birch, a widow who ran the establishment with her two daughters. Ten years later, the property had changed hands again. This time the place was owned by the Westwood family.

Conversations with descendants of families associated with the village imply that the following story occurred between the start of the twentieth century and the outbreak of the First World War. It has to be noted that this narrative has no

written record, indeed it does not seem to have appeared in print before the 1970s. Without a record, it is difficult to judge the accuracy of the narrative. However, it is worth repeating, as you will see.

A former occupant is said to have murdered his wife. After this he is said to have cut up her body and hidden her remains in a drainpipe at the end of the group of buildings, roughly where the present-day kitchens are to be found. Previous landlords who have witnessed 'the Grey Lady' in the bar area suggested that this is the most fitting explanation for what they have seen. Further problems include the lights turning themselves on and off, previously locked windows being found open without any explanation, and the guard dog staring and growling at a part of the room where there is nothing to be seen.

In 2004 a team of investigators and a spiritualist were invited in to the building to conduct a series of experiments. One of the first things reported by the latter was a stocky man dressed in tweed standing in what had been a doorway to the side of the bar. During the time when the cottages had been knocked through, several doors had been closed off in this manner. The spiritualist took pains to point out she was of the opinion that he had once been resident here. She also sensed a barrel of sherry at the end of the bar.

Other members of the team searched upstairs, where they had detected creaking and a distant murmuring noise. These were the old guest quarters and were no longer in use, however the spiritualist found an elderly lady who had passed away peacefully in room five, where there had been a bed to one side of the room. At the time no name was mentioned, although the spiritualist later produced a written report and gave the woman's name as Mabel.

HUNTINGTON

White Lion
When new licensees Michelle and Mole Morris moved here in June 2009, they were not aware that there were spirits other than those dispensed from the optics behind the bar. Twenty years earlier the then-landlord had resorted to moving out of the upstairs living accommodation and had called in the local clergy to bless the premises. The ceremony, not exactly an exorcism, was witnessed by a local reporter, who not only felt a sudden and very noticeable drop in temperature but also saw a column of dancing lights.

Not long after they had moved in, Michelle went into the cellar to change a barrel, something she had done many times in her career. A drop in temperature as she entered the cellar was not unexpected. However, she felt another drop *after* she had been in the cellar a few moments. She sensed someone behind her and turned to see a figure, which vanished so quickly Michelle had no idea if it was male or female.

I

IPSTONES

Beware of the Staff
With Onecote just 3 miles away, the similarities between this figure and the one spoken about on page 87 cannot be denied. However, these are different narratives and thus are treated separately.

A battle was raging somewhere in the south of Yorkshire at a time when it was unified as a single county. A force from Scotland stood toe-to-toe with the English, neither giving an inch. On the English side was a man from the Ipstones part of Staffordshire, reputed to be among the greatest of warriors. This was to be his final battle. Astride his faithful horse, he battled the enemy with a studded staff, and he probably never felt a thing as his head was removed clean from his body with a single blow.

That night a shadowy figure could be made out in the failing light. Having fled the battle, the horse instinctively headed for home. On his back was his headless master, still clutching the reins with one hand and his trusty studded staff with the other. Locals fear the club rather than the man, for it is believed that if it is pointed directly at a person something awful will befall them or someone close to them.

Eternal Thirst
The peace and quiet of a Sunday afternoon in 1650 was interrupted by a knock on the door of the home of a badly lame man. A stranger asked him for a drink to quench his thirst. Inviting the visitor in, the lame man handed him a drinking cup and bade him help himself as he clearly had mobility problems.

The stranger got his drink and took a seat opposite his host, who noted, but did not comment on, the man's highly unusual long purple cloak. The subject of the man's poor health was raised and, without a second's hesitation, the visitor told him the problem could soon be cured. He should take three balm leaves and make a tea with the ale every day. He should also say his prayers like a good Christian and before three weeks had passed he would be cured.

With nothing to lose, the man took the advice of the stranger and was indeed cured inside the time stipulated. Intrigued to know who this oddly clad individual was, he asked around and nobody knew. Despite the man's strange attire, nobody could recall having seen him.

Perhaps the stranger is known to many, for the story of the Wandering Jew – a man who was on the road to Golgotha and was offered a drink of water by Jesus – fits the story neatly. The man refused and was told he would be fated to roam, forever thirsty, until the Son of God returned to Earth.

If anyone is offered a drink by a kindly stranger, maybe it would pay to think twice before refusing.

The Hermitage

While thousands of individuals faced each other across the trenches of Europe, a reporter for a Matlock newspaper crossed the county boundary and brought his notebook to the Staffordshire Moorlands.

The farm was the property of one Colonel Beech and under the tenancy of Bennett Fallowes. Together they had run this place for some twelve or thirteen years, yet the reporter was showing interest in the previous owner, who seemed reluctant to leave his old home. The Fallowes family admitted that their resident ghost hardly troubled them.

During his lifetime, the earlier owner of the place had earned a reputation for miserliness. His permanently bent back made him seem small, despite his never being seen without his top hat. Disliked by all who knew him, he was reputed to have amassed a small fortune. The Fallowes family, who had never met him as he had died before they arrived, were sure he was still there. They often felt the draught and heard the sound of rustling as they passed him on the stairs, yet nothing could be seen.

One day Edward Wheeldon, Mrs Fallowes's brother, brought his wife to stay for a few days. They lasted just one night – a night when they were unable to sleep for the sound of someone running up and down the stairs all night. They tried to call out to the rest of the family in another part of the house, but were unable to make themselves heard. When daylight broke the next morning, Mr Wheeldon saw that his hair was standing straight up. Neither he nor his wife stayed another night.

A servant girl would often hear ghostly screams from beneath her bedroom window. It was a serenade she could certainly do without.

Richard Fallowes, a cousin of the man of the house, stayed one night. He not only heard the American organ playing in the sitting room, he also recognised the tune – yet nobody was downstairs at the time.

A bed in an unoccupied room was heard to be sat on, yet nobody was there and nor could they have exited without being seen.

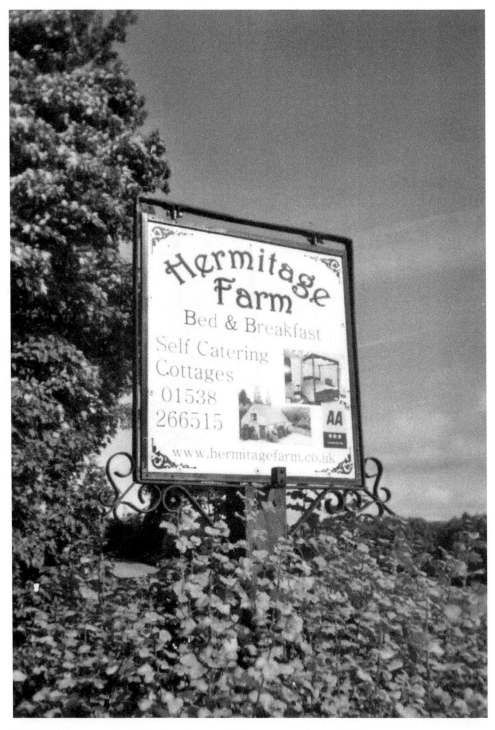

This is all that remains of the hermitage at Ipstones.

The Old Red Lion, Ipstones.

A pile of planks created a tremendous noise as they seemed to come clattering down one evening. However, armed with lanterns, the family discovered that not a single plank was out of place.

None of these incidents were as worrying as that experienced by Jane Fallowes, who felt the unmistakeable touch of a human hand against her face.

The ghost seems to like specific times in the calendar. He appears at Good Friday, Easter, Whitsuntide, Christmas, and the summer and winter solstices.

A large black dog – said to be the size of a donkey, and with glowing red eyes – may or may not be related to the other phenomenon. It has been seen in the road around here. One man kicked out at the fearsome beast, only to see his foot pass straight through the animal, which seemed not to notice.

The Old Red Lion

A spinney, just a stone's throw away from yet an example of the most common pub name in England, was well known to the locals as a place that should be shunned whenever possible. Several of those who did come here reported feeling the presence of a young woman, while others claimed to have seen her. However, it was not until the mother of the victim reported having had a recurring nightmare that the reports were taken seriously.

One can only imagine the distress for the mother, who must have dreaded falling asleep only to find her daughter telling where the buried body could be found – the spinney.

Phantom Cyclist

At a bend in the road not far from The Old Red Lion there has been a recurring sighting reported by at least four different individuals on separate occasions. Three people are seen standing looking down at a bicycle that is lying on the ground; the rider is not to be seen. As the observers near the scene, all three people and the fallen bicycle promptly vanish.

K

KEELE

Portman Road Pilgrims

Many drivers travelling along the M6 motorway only know Keele for its service station, built in 1963 between junctions 15 and 16. It was not the tea or sandwiches that hit the newspaper headlines in January 1974.

Ipswich Town Football Club was among the leading clubs in the land at the time. Under manager Bobby Robson, who later took the England team to the semi-finals of the world cup, the club regularly qualified for European competitions and produced some of the finest players of the 1970s. Ipswich has always been known as a club with a loyal following.

Two supporters were making the long car journey home to Suffolk on Saturday evening and stopped to take advantage of the facilities at Portman Road.

In the gents' toilet they saw a man dressed in quintessential Puritan attire; the only other person there. His wide-brimmed hat, jacket and breeches of dark hose, shoes with buckles and large white collar and cuffs was very worn and looked even older than the wearer. He left the toilets shortly ahead of the football fans. Thinking he was an actor, possibly someone of note, they quickly hurried after him. However, rounding a corner they found he had vanished.

They asked about and it began to seem as if the figure was no twentieth-century actor. There is no record of another sighting of anything untoward here since that time thirty-five years ago.

While the football supporters may have been taken aback by the experience, it may have been even more of a shock for the Puritan. Among the many laws passed during the Interregnum to reflect the strict beliefs of the day were a ban on dancing and singing, no gatherings of people without permission, sundry sports (oddly enough including going for walks on Sundays), drunkenness, swearing, and the closure of many pubs.

This is not to suggest these particular football supporters were foul-mouthed or intoxicated. Yet singing and chanting are essential ingredients in British football, and the pair may well have been wearing blue and white scarves. Ornamentation was seen as a sin; maybe the stranger's shock caused his sudden disappearance.

KIDSGROVE

The Harecastle Canal Tunnel

Strictly speaking, this should be referred to in the plural, for there are two tunnels, the Brindley at 2,880 yards and the Telford at 2,926 yards. The latter is the only one still navigable today.

A headless woman has been reported in the reeds here. She is said to be the spirit of a woman murdered, decapitated and thrown onto a landing stage for coal within the tunnel called Gilbert's Hole sometime during the nineteenth century. The spectre is also said to appear within the tunnel itself – sometimes as the woman and again as a spectral white horse. This apparition is normally referred to as the Kidsgrove Buggut, sometimes as Kit Crewbucket.

Allan and Debbie Jones, who have given over a large part of their lives to being afloat on the canals of our islands, have recorded sights and memories on their website www.keeping-up.co.uk. Part of their travels brought them to the mouth of the Harecastle Canal Tunnel in 1990. This part of the journey is reproduced here in their own words and the author is indebted to Allan and Debbie for their generosity in volunteering their remarkable personal experience:

One fine day in 1990 a line of boats was waiting to enter the North end of Harecastle Tunnel. The last boat heading north came out of the tunnel, and the tunnel keeper said it was OK for us to go in. 'No, no, no,' shouted the steerer of the emerging boat, 'there's an old working boat following us, we can still see his headlamp.' So we all waited but no more boats came out. The tunnel keeper looked, and couldn't see anything, so he phoned the south end keeper who confirmed that there were no other boats heading north, so we all started untying our ropes and got ready to enter the tunnel.

Suddenly the leading cruiser came backwards out of the tunnel again. 'He was right,' he said, 'there really is a boat coming this way.' We all waited, and again the tunnel keeper phoned through to the south end, but again no other boat appeared.

The leading cruiser went into the tunnel for a second time, only to come flying out again at full throttle backwards. The steerer was as white as a sheet, and trembling from head to toe. 'Here it comes, it almost ran us down that time,' he cried, and stopped to watch as we were all proved wrong. Except that we weren't proved wrong, and nothing came out of the tunnel.

'Let me have a look,' said the tunnel keeper. 'I'll come into the tunnel with you,' He stepped onto the cruiser. Suddenly the steel barrier swung across, right through the cruiser's window. Six strong men were assembled, but their combined strength couldn't shift the barrier. 'That's enough,' said the cruiser owner, 'I'm not going into the tunnel.' Silently and smoothly, all by itself, the barrier swung back from the window and placed itself back against the wall.

The cruiser went back the way he had come, and we all set off into the tunnel. The ghost boat with its light had vanished without a trace. We all went through the tunnel, and saw nothing.

Perhaps you think I am making this up, but I swear that every word is true. I'll never forget the absolute certainty in the voice of the steerer heading north, and the terrified look on the face of the cruiser owner. Just why the Kidsgrove Boggart didn't want the cruiser in his tunnel will forever be a mystery, but I for one will never, ever again say that I don't believe in ghosts.

The Kidsgrove Buggut

This story appeared for the first time in writing two centuries ago in the journal of Hugh Bourne, a Methodist preacher of note. It seems probable that this story was told much earlier and may be many centuries old.

On a night in 1816, Bourne was at Talke o' th' Hill when he learned of an accident in the coal mine that had injured several men. Furthermore, the Buggut was held to be responsible. This Buggut he describes as something invisible, known by its strange groaning and awful moaning. Bourne blamed the creature for all manner of tragic events, describing how it could be heard moving about the streets only to stop outside a house – whereupon an accident befell the inhabitants.

In the mid-twentieth century, Norman Roche gathered eyewitness accounts of the Buggut. He described how the Kinnersleys of Clough Hall invited a cousin to spend some time with them, Mrs Napier having seen something that may have a link to the Buggut. The lady was in the rose gardens enjoying the blooms when she saw a woman walking on the rose beds. Thinking this was an act of wanton vandalism, Mrs Napier approached the woman, hoping to ascertain the reason for her actions. As she drew nearer, a feeling of great sadness overwhelmed her and she instinctively bowed her head. That was when she noticed the woman was wearing period costume and, as her eyes followed the stranger, she noticed the woman had no head. The woman then walked straight through the hedge without disturbing a single leaf or twig.

Feeling she would be accused of being insane should she speak to the Kinnersleys, Mrs Napier approached the head gardener, who had been working nearby, and asked if he had seen the woman. His reply was not what she had expected, for it transpired that several of the gardeners had witnessed the same thing but had

always thought it a result of the demon drink. It was then she learned that the apparition had been christened the Kidsgrove Buggut.

Another story in the Roche collection concerned a Mr Brookes and his companion, who were walking near the top of Boathorse Road. They spied an unusual figure with the appearance of a lonely housewife leaning on a nearby gate. They started to approach to see if they could render assistance. Suddenly the figure rushed past them and vanished, although when they examined the area where the figure was last seen there was no sign that anyone or anything had been there moments earlier. Indeed, the area around here was surrounded by a plain unbroken wall, a barrier where the only means of escape was to vault it – a most unlikely thing for a housewife to do, but something that seemed quite plausible to Mr Brookes.

KINVER

The Compa
This story takes place in that oddly named road of The Compa. This is a very old road indeed and has been the venue for a ghostly visitor for as long as anyone can remember.

Always referred to as Old Joe, this figure is a man aged about fifty clothed in the working attire of his day – heavy work boots, cloth cap, brown trousers and matching waistcoat, with a well-frayed collarless shirt. Some reports give him a bushy moustache, others note no such adornment.

Nobody has any notion as to the identity of this regular visitor, who is certainly better known as a ghost than he ever was when alive. Indeed, rumour has it that one elderly couple were visited so regularly they took to setting a place for him at the dining table.

L

LEEK

Ball Haye Road
At one time a house here was occupied by three sisters, all of whom were spinsters. One day one of the trio brought home a gentleman friend, which was the catalyst for some very worrying events.

Almost immediately items took on a life of their own. Saucepans leapt to the floor, pictures that had hung perfectly straight for years were found hanging at all angles, and electric light switches turned on and off. Clearly, whatever presence was in this house did not approve of the man.

Blackmere Pool
Even the name is enough to instil a chill. The ridge of land high over the town of Leek seems an odd location for an almost circular body of water 50 yards across. However, perhaps the explanation is to be found below the surface of the very dark waters, in one of the strangest stories to be found in Staffordshire.

Not only is Blackmere Pool 30 miles from the sea, it is over 1,300 feet above it. It is rather surprising, then, that it is said to be the home of a mermaid. Every night at the stroke of midnight she rises to the surface to comb her long hair. Anyone wandering past at this time who is seen by her will be dragged down into the cold, deep waters.

There is a public house nearby that is named after the legend. It features the fabled female brushing her hair and is known as the Mermaid.

John Naden
At noon on Tuesday 31 August 1731 John Naden was whispering his prayers, presumably asking for forgiveness. It is not recorded if he reached the end before the ladder was removed and the noose locked tightly around the murderer's throat.

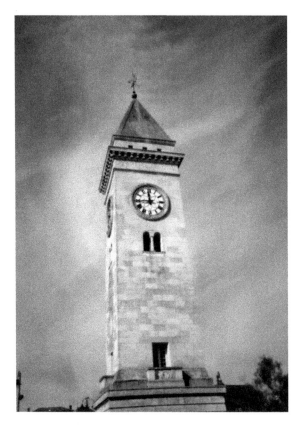

Leek's most noticeable landmark.

Born and raised to poor parents in Leek, Naden found employment as a servant at White Lee Farm on the Staffordshire/Cheshire border. The farm was owned by Robert Brough and his wife Julia. Naden soon became a most popular figure; he was said to be tall, handsome, well-spoken and impossible to dislike. His popularity received a further boost when he saved Robert Brough from drowning after the man fell into the swollen floodwaters of the River Dane – an ironic episode in the lives of both men, for had Naden not rescued his master the ensuing events would not have happened.

Julia Brough was an attractive woman, significantly younger than her husband, whom she despised. She had noticed the young man and became increasingly bold in her attempts to show Naden she was interested in him. Inevitably a passionate affair started. She even gave Naden a ring professing her undying love and increasingly nagged him to end her misery by making her a widow. The farm would then be theirs.

The affair was hardly a secret. The landlord of the Cock Inn told Robert Brough about it, but he would not hear of such malicious gossip. He trusted Naden implicitly. Julia was greatly perturbed by these rumours and pressured her lover by

threatening to end their liaison and find someone else to do the deed – there would be many to choose from as Brough was almost universally disliked.

John Naden eventually agreed and set off to intercept his master, who was returning from a short journey. However, his conscience got the better of him and Naden returned to face the wrath of the woman he undoubtedly loved. A vociferous argument raged on as the master approached his home. During his journey, Brough had heard again and again of the affair – even from people he did not know – and had decided to end these rumours. As soon as he got home he sacked John Naden and at a stroke sealed his own fate.

Naden followed his former employer to Leek market. Placing a large stone against a gate, he ensured Brough would be forced to stop and climb down to remove the obstruction on his return journey and then waited in ambush. Sure enough Brough reacted exactly as planned and Naden leapt upon him. Fuelled by drink, he slashed wildly at Brough's head and throat, also causing deep cuts to the arms, which the victim instinctively raised to protect himself. The kitchen knife inflicted such deep wounds the coroner later commented on how the head had almost been severed from the body.

Rushing from the scene, Naden was greeted at the farm by the jubilant Julia. It was then they realised his mistake. The murder weapon had been taken from the farm and had been left at the scene. Julia told her lover to clean himself up and calm himself, while she returned to her husband's body to retrieve the knife. She flung the knife into bushes and removed the contents from the pockets to make it look like a robbery. The finger of suspicion would doubtless be pointed at William Wardle, a pedlar and sworn enemy of Brough.

But the murderer had made a second error, one that could not be covered up. Dazed and ashen as the realisation of his actions dawned on him, Naden had a drink. The normally calm and confident young man was a blood-stained nervous wreck – a fact not lost on the barmaid, who reported what she had seen to the local constable. Naden was arrested the next day, taken to Stafford Gaol, and brought before the Assizes on 19 August.

Pleading 'not guilty', Naden blamed Wardle. However, the pedlar was soon acquitted of all blame for a number of witnesses came forward to prove his innocence. The evidence against Naden was overwhelming and he was sentenced to death. A week later he broke down and confessed, telling the whole story from the beginning. Julia Brough was neither tried nor even charged for her part in the crime – the only evidence lay in Naden's confession and that was insufficient to prosecute.

Three days later, he was taken from Stafford to Leek, where he was held at the Cock Inn awaiting his execution the next day. Every inn and tavern in Leek stayed open all that night, men and women from all walks of life drinking the town dry of ale and

Does John Naden still wander the moorlands around Leek?

then turning to stronger spirits. Needless to say, by the time the execution party set off for the hill the next day the crowd were rather rowdy and baying for blood.

The noose was thrown over a branch of an apple tree, fittingly one belonging to the victim, and Naden ascended the ladder. Turning to the crowd, he asked their forgiveness, particularly that of William Wardle, whom he had attempted to blame for the murder. Then Naden prayed. When the ladder was snapped from beneath him, his body jerked spasmodically. Gurgling sounds came from his throat and for what seemed an age to the now-quietened crowd, arms and legs kicked and flailed about wildly. Forty-five minutes later the body was taken down and transferred to Gun Hill, where it hung over 20 feet from the ground in a gibbet of chains to remind others of what fate awaited them for their crimes. The body remained there until it fell apart.

The gibbet that held Naden for so long was taken down and, as was normal at the time, the wood was reused for other projects. Three posts and a number of stiles hereabouts appeared soon after. Today the lanes and fields are said to be where John Naden is doomed to wander a route that takes in every gatepost and stile made from the recycled wood.

Stockwell Street

Once known locally as Dicky's Gutter, the narrow passage here led through to Brough Park.

During the latter half of the twentieth century, on an evening just as light was beginning to fade, a pedestrian was astonished by the approaching sight. Striding purposefully towards them was a man – a Cavalier complete with long, flowing black hair, period clothing, and a sword slung from his waist. The witness was frozen to the spot by the sight, only able to watch in amazement as the figure came past without any indication that he was aware of his strange twentieth-century surroundings.

The Swan

As the oldest pub in Leek, dating from around 1620, it would almost seem to be a crime if there had been no paranormal reports. Opposite the local parish church dedicated to St Edward, the pub's impressive black and white frontage has welcomed many a famous face over the years. One room is the Tolkien Room after J. R. R. Tolkien, who penned many lines when he stayed here, perhaps even something of his most famous works, *The Hobbit* and *The Lord of the Rings*. Today is no exception, indeed the place was recently bought by the Crafty Cockney himself, former World Professional Darts Champion Eric Bristow. True enough, the Swan is reputed to have had more than a few ghosts over the years

Soon after Eric took over the establishment, at least one has manifested itself. The new owner was keen to spend a little money on giving the place a bit of a facelift. Although he has never seen a ghost himself, many of his staff have been bothered by these undrinkable spirits.

As with many old pubs, there are several rooms, one of which, reached via a side door, is known as the Sports Bar. Here typical pub games are played – pool, dominoes and of course darts – with a giant screen enabling fans to watch live Premier League football, Wimbledon, the Ashes, or even Staffordshire's own Phil 'the Power' Taylor aiming to win yet another darts title. A barmaid was working there at eleven o'clock one Saturday morning, shortly after opening, when a bottle hit her hard on the back of the head. She ran up the stairs in blind panic. Upon hearing the news, the rest of the staff came down to the bar. No sign of anyone having been there could be found and no sign of the glass weapon could be traced. However, the lump on her head was all the evidence the barmaid required.

Upstairs are a maze of rooms where guests have often complained that, while shutting the door is a simple task, when it comes to opening them again it is quite a different story. Opening easily one moment, it is then locked solid and no amount of pulling and pushing will move it. Seconds later it will swing freely.

Eric's daughter Louise has also been spooked when working here, although the darts maestro himself has never be party to anything, and nor is he bothered by

these stories. He does hope to see evidence himself one day yet, though. In his words, he hopes 'it's without fifteen pints of Guinness!'

Westwood Hall

The most famous occupant of this house was John Davenport, a highly successful entrepreneur and industrious individual who served as a magistrate and deputy lieutenant for the county. His humble beginnings did not stop him showing his flamboyant side, such as when a procession of his workforce walked from Longton to Burslem to celebrate the victory over the French at Waterloo. Davenport and his works manager James Mawdesley both wore glass top hats and carried glass walking sticks specially made for the occasion.

Later the house was utilised as an educational establishment, first as Westwood High School and today Westwood College. It was in 1959, when it was a school for girls, that an old haunting story was revived. No individual pupil admitted to witnessing the haunting and staff denied it had ever happened, yet this was an old story that had not been heard for many years.

Legend has it that the ghost is Lady Tempest Vane, who had been killed while attempting to leap a double gate when riding her horse in the grounds of the previous hall on this site. Her body was entombed in the cellar of the old hall. Years ago, following complaints from the owners of the hall, local clergy performed an exorcism. However, it seems their efforts were in vain for she has been seen, draped over a gate, illuminated by moonlight.

LICHFIELD

Benjie

This friendly ghost seemed more playful than malevolent when he made an appearance at the dry cleaning shop in Market Street. He made his presence known by slamming doors and unrolling the toilet paper in the ladies' toilet, while also getting up to mischief with the clothes and paperwork.

Despite his playful demeanour, he is thought to be the ghost of a murder victim in a nearby pub. The name of Benjie is something of a mystery, although one theory puts it down to being the name of the dog of the murdered man.

Bird Street

The King's Head in Bird Street has a long history. Three centuries ago, Lord Luke Lillington took the decision to found the Staffordshire Regiment, which is now based along the A51.

With few regular professional soldiers in those days, unscrupulous methods were employed to find volunteers in troubled periods. One of the most common

was by dropping a shilling into the ale of an unsuspecting soul. When he reached the bottom of his drink he found the coin and was deemed to have 'taken the king's shilling', i.e. received the pay of a soldier and thus signed up. To lose regular customers in this way, especially as it was possible they would never return, was not good for landlords, and so they invested a little cash to strike back. In tankards with a glass base the coin could be seen and the drink ignored – thus many local men saved themselves from going to war.

No uniformed ghosts are reported, however there are three quite different spectres here. One is the sad sight of a young girl, said to be the tragic victim of a fire. The city suffered a devastating fire in late 1681 or early 1682 and another in 1697. The wooden buildings' thatched roofs and the narrow streets meant sparks and flame could spread easily. Building materials were highly combustible and fire-fighting methods highly ineffective. Perhaps she died in one of these fires, for there is no record of a fire specifically at The King's Head. This girl has been seen and heard many times, both inside and outside the premises.

The second apparition is more predictable; it is only ever seen in the cellar and then only late at night or in the early morning. The shadowy form is said to be that of a former licensee – a man who took his own life in this very cellar at the end of a rope. No name nor time period is known for this man, hence we have no idea why he should have desired to end his life.

Our third ghost is the most famous and one that can be dated, albeit roughly. The city hosted several engagements during the 1640s, when Royalists and Parliamentarians did battle. One Cavalier soldier met his death in Bird Street; outnumbered by Cromwell's men, he was hacked to death outside The King's Head. There was no Christian burial for this unfortunate – he was simply dragged into the cellars and left to rot.

However, it seems the man had the last laugh, quite literally. His ghost has been seen around the centre of the city, presumably enjoying an evening constitutional. His wounds have never healed and have been described in graphic detail by witnesses to his roamings. He is often seen along Dam Street too, before making his way back to the scene of his death. Furthermore he is always seen as deliriously happy, hence he is known as the Laughing Cavalier, after the famous painting by Frans Hals.

In 2002, proprietor Jenny Matthews heard a noise from upstairs, where the function room is situated. Knowing nobody should be there, she went upstairs to investigate, but not before making sure she had the dog with her. As she neared the door to the function room there was a quite distinct knock on the door from inside. She was not mistaken, for the dog had clearly heard it too. Carefully opening the door, she found nothing at all – no intruder, no customer, no member of staff and nothing untoward.

The King's Head, Bird Street, Lichfield.

The coming of the twenty-first century has not put an end to the unexplained in Bird Street. Glasses shoot off the bar without a living soul within reach. Empty bottles are found broken in the conservatory, yet nobody had been in there since this area was closed and secured. While footsteps have echoed along corridors, where no mortal could have been walking.

The Close

A tenant of the houses around The Close, properties of the Church, explained how she felt there was more than just herself and her husband resident in their house.

For some time, in an area upstairs at the rear of the house – either in the main bedroom or on the landing – an inexplicable cold spot had been noticed. This is an old house – draughts are almost inevitable – and for some time this seemed to be a satisfactory explanation. However, other clues that were more difficult to explain were soon to manifest themselves.

In the same area of the house as the cold spots had been noticed, the tenant started to notice an overpowering smell of lavender perfume. Even more strangely, considering the kitchen was not directly below this part of the house, they have noticed the smell of cooking. Not a general cooking aroma, this was one of two things: either 'a good wholesome stew' or a sweet, mouth-watering pudding.

The Close, Lichfield.

There is no suggestion of why this happened. The ghostly cook seems to have no idea of the time, for what are clearly main meals are detected early in the morning, sometimes before the tenant and her husband have even risen from their bed.

Coach and Horses

As mentioned in the introduction, the author's only ghostly experience was fleeting. It was the middle of the 1990s and an evening in October or November when the following happened. The story is here told in its entirety for the first time.

That Monday had been very long and particularly tiring. I had started at seven in the morning and the working day was still not at an end as nine o'clock that evening approached. Darkness had fallen by the time I was able to make my way to Lichfield to collect my daughter, who was attending a ballet class. The road comes through Whittington and skirts the southern edge of Whittington Heath Golf Club before coming to where Whittington Common Road joins from the right. It is at this point that the road bends to the left and drops down into the city of Lichfield itself. Today the speed limit drops to forty at the top of this incline, although at the time it remained at sixty the bottom, 200 yards further on. There was but a single light on the right, by those few houses near the top of the incline, while the street lamps did not begin until after the entrance to Lichfield Rugby Club.

The headlights of my dark green Peugeot 309 were on full beam as I swung around the bend and shone down the slope to illuminate a bank of mist in the natural dip at the bottom of the slope. There was no mist or light between my car and the dip at the bottom, and the road beyond was quite clearly illuminated by the street lighting; it was crystal clear when I drove there shortly afterwards.

As my headlights swept across the wall of mist stretching from the pub on the left, I fleetingly saw a glimpse of a vehicle dashing from left to right. Travelling at breakneck speed was a coach and horses. By the time I had noted it, the sight was no more, although the mist was still there. I recall collecting my daughter and, rather than feeling shocked, surprised or spooked, I was already planning to find out more about the experience.

Always priding myself on being a logically minded and rational individual, I mulled over the experience. It should be noted I never contemplated writing about my ghostly experience at the time. I was neither a sceptic nor a firm believer. Indeed to this day I have an open mind and would welcome the opportunity to be shown such phenomena are echoes of the past.

Thus within a few days I found myself at Lichfield Record Office examining old maps dating back to Roman times, several hundred years before the coaching era. Today there is no road leading between the rugby club, past the Horse & Jockey pub and across the A51 to the fields beyond. The maps showed there has never been a road here in the last 2,000 years. If ghostly sightings are a 'memory' of the past, then my experience does not fit the theory.

Another clue that this may not have been what I first thought was the speed this vehicle was travelling. In the best possible conditions, such a vehicle would never better a speed of 40 mph and yet here the path was across rough, open country. Furthermore, what I saw was travelling at well over 100 mph – an impossible speed for any vehicle over this terrain either today or in the foreseeable future.

Ever since that evening I have thought about what I experienced and feel what I 'saw' was in my mind and not in my field of vision. Why I would be thinking about a coach and horses I shall never know, however it is possible I was recalling the name of that pub on the right, which, even today, I often mistakenly refer to as 'the Coach & Horses', when the correct name is the Horse & Jockey.

Darwin House

There have been reports of a man with a beard crossing the road outside the house near Beacon Park. This was said to be Erasmus Darwin himself, crossing the road to reach his herb garden. Erasmus Darwin (1731–1802) is most often described as the grandfather of Charles Darwin, however he was a famous physician in his own right, and also a founding member of the Lunar Society, a group of industrialists and philosophers that included James Watt; Matthew Bolton; Thomas Day; Richard

Right and below: Darwin House, Lichfield.

Lovell Edgeworth; Samuel Galton, Jr; James Keir; Joseph Priestley; William Small; Jonathan Stoke; Josiah Wedgwood; John Whitehouse; and William Withering. A select group indeed.

Erasmus Darwin certainly had influence and an inquisitive mind. However, at no time did he wear a beard and furthermore the herb garden was not on the other side of the road but in a field some 2 miles away – a place that Erasmus would have travelled to by horse and trap. So it seems this unexplained figure must have been someone else.

Within the house is a different story. Lights switched off in the cellar have been found turned back on a few moments later and yet nobody has entered the room. At other times a boy and a woman have been seen on the stairs. However, the strangest encounter occurred in 2009.

Elizabeth Stewart is a member of staff. One event in 2009 required several people to be wearing costumes, hence it came as no surprise to find a man in period dress on the stairs. For the most part he was unremarkable, just a little over 5½ feet in height, with a slim build and mousy brown hair. His attire, however, was rather unusual – as well as his unexceptional black bow and shoes with a silver buckle, he wore a tricorn hat inside the house – an unforgivable *faux pas* – and a pink suit.

So memorable was this pink suit that Elizabeth mentioned it in passing to another member of staff. To her disbelief she was told there was no one dressed in such a suit.

The Duke of York
A fourteenth-century public house on Greenhill, the Duke of York was reopened in late 2009 following extensive refurbishment. However, we shall concentrate on the period leading up to temporary closure of the premises the previous year.

Even during the first years of the twenty-first century there were several sightings by the regulars. The pub has its own ubiquitous Grey Lady, seen walking through the rooms, while an elderly man and a Cavalier from the English Civil War era have also been identified.

However, the most interesting encounter happened in 2004, when then landlady Susan Beacock was in the cellar. Steps lead down from street level, providing access for the draymen. However, on this day the steps were occupied even though the trapdoors were still locked and there was no delivery due. Susan was understandably surprised to see a figure with a full beard and moustache wearing a cassock and a high, pointed, wide-brimmed hat. Taking a deep breath, she told the figure, 'Go away, you don't frighten me.' Promptly, the figure vanished.

Other unexplained electrical problems – lights turning on and off by themselves and the jukebox suddenly coming on at full volume in the middle of the night – were not as strange as the cellar. Here, after the meeting with the mysterious

figure on the steps, Susan was never able to use those stairs. It was as if an invisible wall was in her way.

Fred

Christmas 1972 was unremarkable, save for the coveted Christmas number one spot being filled by the decidedly non-festive 'Long Haired Lover From Liverpool' by Little Jimmy Osmond – an offering that somehow managed to top the UK charts for a total of five weeks.

Three days after the presents had been opened there was a lull in proceedings. In those days we returned to work between Christmas and New Year. The coming 1 January was only the second to be a bank holiday in England. Yet there was a customer waiting to be served at the Acorn Inn on Tamworth Street. Experienced barmaid Thelma Bird suddenly became aware of a man dressed in black and standing at the bar. She approached in order to serve him, but before she had asked what he liked to drink he disappeared into thin air.

Regulars learned of Thelma's experience and, rather than ridicule the respected barmaid, decided to adopt and even name him – hence from that day he has been known as 'Fred'.

The Gallery

Built around 1650, this building was 'handed over' when the earl ran up huge gambling debts. Just one ghost has been reported here – a regular visitor who turns up in October and who has been smelled more than seen; his appearances are marked by the very strong aroma of fish.

Market Street

There is a building on Market Street that is at least 300 years old; for a decade or so has been selling leather goods as Golunski. It has five floors, including the cellar and loft.

A young woman once worked there on Saturdays and during the holidays when not at college. At that time the name above the door was Mercer's and the shop sold sports and leather goods. As always, the upper floors were used as stock rooms and visits were kept to a minimum as there was an eerie atmosphere. What was even creepier was the greater tension in the air at the unusual hour of 11 a.m.

The Mercer family had owned this place for several generations. Gill Mercer was the last. She witnessed lights being turned on and off, shelves disorganising themselves overnight, items being thrown about, hot and cold taps running without being turned on, doors slamming shut with nobody near, and the trap door to the loft opening when nobody was near.

These problems were not restricted to the movements of inanimate objects. Gill Mercer saw a woman in the cellar some years ago. The cellar was rarely visited. Sightings of a man on the upper floors had been reported ever since the days of Gill's grandfather, many years before. As with many ghosts with the 'lovable rogue' image, he was given a name – Henry.

However even lovable rogues can outstay their welcome and eventually the clergy were summoned. This did not result in an exorcism but a blessing, yet it seems to have done the trick. As far as we know, Henry's visits ended quite abruptly and, as far as anyone is aware, he has not returned to Market Street.

Odd Reflections

The Pig & Truffle is another pub that claims to be haunted. As elsewhere, glasses have been known to fly across the room. Here they smash as they connect with the far wall. However, the strangest and most inexplicable manifestation can be seen in the mirror, or perhaps *not seen*, for it is said that at times the reflection viewed in the mirror is *not* the mirror image of the room.

It cannot be denied that there are a very high number of ghostly sightings in licensed premises. This leads to the inevitable suggestion that alcoholic spirits are very much to blame. It should be noted that the majority of pub ghosts are seen outside normal hours and by those working there rather than the customers. Furthermore, there are also a number of ghosts reported at churches, which are never considered alcohol-induced. There is a rational explanation, however: the pub and the church are traditional meeting places after dark, and this was particularly true in times when the majority of the nation earned their living directly off the land.

Problems for the Organist

Around the time of the turn of the millennium, an organist at St Chad's church was plagued by interruptions during his hours of practise. The lights would switch on and off of their own accord, as would the power to the organ's electronic bellows.

A building of this great age can have no shortage of potential ghosts, for the present building is largely twelfth-century.

St Chad

Chad was made Bishop of Mercia in 669 and moved his see from Repton to Lichfield. Why he chose Lichfield is unclear; any suggestions would be purely speculative. We do know the first cathedral was completed in AD 700, some twenty-eight years after its founder's death. His shrine became a place of pilgrimage.

The Mercian King Offa decided to create his own archbishopric in Lichfield rather than submit to the influence of Canterbury. His plan was approved by Pope

Lichfield Cathedral.

Adrian, but the archbishopric only lasted until Offa's death sixteen years later. This first Saxon cathedral was of wood, but from 1085 this was replaced by a Norman stone building. The present Gothic building was started in 1195 but was not completed until 1330. According to the writings of the Venerable Bede, Chad was declared a saint immediately after his death, even though canonisation is normally only considered a minimum of twenty-five years after the individual's death.

Within the present building the area dedicated to its founder is found within the part known as St Mary's church. Near the prayer room high up in this chapel a figure has been seen. Is this the founder, still keeping an eye on the place of worship that bears his name?

Sandford Street
The property in question was built during the sixteenth century. However, the beginning of this story takes place later, when the daughter of a former owner lost her life.

There is no documented record of the incident, but the story of the girl who was killed in terrible circumstances is now etched firmly into local folklore. For reasons

unknown, she was in a tunnel off the cellar when the ground collapsed, burying her alive. It is said that, decades after the event, later owners were baffled as to why their normally fearless dogs refused to enter the cellar.

It took until 5 August 1983, when pet shop owner Roger Elmsley heard odd noises in his premises. Shadows seen in an otherwise empty room, the sound of disembodied footsteps, and the feeling of a strange presence all convinced him he was not alone. It was then that he learned of the story of the tragic loss of the young girl centuries before. Roger was convinced it was a direct result of him rearranging the items in the cellar, since visitors from beyond the grave are often said to become irritated by any change to their environment.

On 28 June 1991 a cleaner claimed to have seen the girl. The ghost suddenly appeared in front of her when she was working. The girl even spoke, telling the astonished woman that her name was Elspeth before vanishing as quickly as she had appeared.

Spellbound Bead Company

A 400-year-old property in Tamworth Street that is currently home to the crafts shop was once the hat shop of Mrs Hall, whose husband saw a mother and daughter in the oldest part of the building to the rear of the shop. Within the shop itself, an assistant, who was alone at the time, let out a sudden scream when she felt the icy touch of something she could not describe.

On another occasion, the proprietor spent ages on a splendid arrangement of flowers after normal opening hours. The next morning, when she entered the shop, she found every single bloom had been removed and strewn hither and yon. Shortly afterwards she had taken time and extra care to ensure a rather expensive hat was returned safely to its box and returned to its space in the storeroom. A day later, the hat was found in the middle of the staircase and no longer in the box, which was still in its place on the storeroom shelf.

After the premises changed hands, the unexplained events continued unabated. The oldest parts of the building, no matter the weather outside, are forever icily cold. Proprietors have described several individuals being followed upstairs by a young girl who beseeches that they return her china doll; others have described a military man whose bearing is indicative of a man used to enjoying the privileges and respect associated with high rank.

One of the most inexplicable reports anywhere in the county is found here. Despite what we would think, smell can often imply as much as the other senses. Here this is not the case, however, for it is very difficult to explain the overpowering smell of strawberries. What is even more mysterious is the timing, for this only ever appears at the same time of day – in the very unseasonal months of October and November.

Stychford Gardens

Now we look back fifty years, to 1962. The only door to a vacant upstairs room in a house near Stychford Gardens was bolted from the inside.

Managing to break the door open, the owners of the house found that the loft door, which led from this room, was wide open. Fearing they had had an unwelcome visitor, they sent for the police. Despite a thorough search, the police and owners could find nothing missing, found no fingerprints other than those who lived in the house, and could find no access to the room other than through the loft, for the windows were also securely shut from the inside.

Clearly the intruder had entered through the loft. However, this was also impossible, for there is no access to the loft, other than from the room. The police and the occupants were reluctant to suggest the intruder was not of this world, but had no better ideas.

Tudor Row

In 1980, the old glasshouses had been demolished and shops were built in the alley. This narrow and novel shopping area was named Tudor Row after the Tudor House – i.e. the building and restaurant alongside which you emerge at Tudor Row's lowest end.

Within the last ten years, one of the retail units here was the site of unusual activity that has never been explained. Stock, which had been perfectly organised at close of business, was found to have been moved the next morning. The racks on which the stock was held have been known to shake, locks have been turned without a key, and taps have been turned on in rooms that are empty.

LITTLE HAYWOOD

Meadow Lane

Ever since the First World War there have been stories surrounding the main road between Stafford and Rugeley, now the A513. At Little Haywood it comes close to the Trent and is crossed by Weetman's Bridge, a stone bridge built in 1887 to replace the earlier wooden bridge, itself little more than fifty years old at the time. Previously carts and livestock had forded the river – not a pleasant prospect in the summer months and a horrendous thought in winter.

Meadow Lane extends across the other side of the main road to Stafford. It was here, between the wars, that a water engineer met with a fatal accident at a pumping station. The circumstances have never been clear, yet somehow he was found to have fallen down the vertical shaft. By the time the accident had been discovered the poor man had died. Having fallen in head-first he had choked to death. By the time the alarm was raised it was already too late; a fireman was winched down in a bucket to retrieve the poor man's body.

Ever since that time, there have been stories of a cyclist travelling the main road between here and Rugeley. Always appearing in daylight, he is said to be riding a very old style of bicycle and has a tendency to vanish as rapidly as he appears. The link to the dead water engineer is that the deceased always cycled to and from work along this road.

LONGTON

Empire Theatre

Opened as the Queen's Theatre in 1896, this long-demolished venue showed moving pictures from 1911. It was renamed the Empire in 1921, when the upper balcony area was sealed off and a false ceiling was added, reducing the capacity but allowing for a projection room. It was around this time that a member of staff was killed when he fell from the lower balcony. His neck broke; death was instantaneous.

In April 1966 the final film was shown, the audience filing out on 2 April having seen Elvis Presley in *Harem Holiday*. Soon it was a bingo hall and the building had acquired a Grade II listing. In 1971 the caretaker, Alfred Newman, reported seeing a figure gliding across the lower balcony. Bravely the caretaker approached and saw a middle-aged man gliding in and out of the front seats. Two days later, Newman saw the same thing in the same place. This time he had his dog with him, and the animal was clearly agitated – its fur bristled. Then the caretaker shouted to the figure, who, bending over the rail, vanished before his eyes.

A fire destroyed all but the facade of the building on New Year's Eve of 1992. Despite calls for the building to be rebuilt, the remains were pulled down in 1997 and no further sightings are known.

Gladstone Pottery Museum

First opened to produce Gladstone pottery by the Shelley family in 1787, the premises were bought outright by John Shelley in the early nineteenth century. Firing ended in 1960, but the painting and distribution of pottery continued until 1970, when the factory was closed. Due for demolition, it was purchased and reopened as a museum in 1974. The familiar bottle-shaped kiln now contains original workshops and ovens alongside the modern museum exhibitions.

When the museum opened, there were immediately reports of an extra member of staff. Many have heard the ghostly footsteps of someone running through the premises, clearly in a hurry. Some also report that this is accompanied by doors being flung wide open. One security guard pursued the noisy footsteps, only to reach a dead end. No one was there.

The colour room seems to be the centre of activity. On the shelves, paints and glazes have been rearranged. Light bulbs and stones have been thrown across the

empty room. Thermal cameras have imaged the heat of handprints on the jars, but have not picked out the heat of any part of the body of the owner of the hands.

In 1978, a member of staff heard the stories of a ghost on the premises and dismissed them as the result of a fertile imagination. That was until he was checking the building for stragglers after closing time and found a non-paying visitor. An old man with grey hair and a fine set of whiskers was seated at a bench wearing a smock, as if at work in the painting department.

It took a few days for the man to pluck up the courage to mention what he had seen, and yet almost every member of staff to whom he spoke had either seen or knew someone who had seen the same old man. A member of the public even pointed out there was still 'one more to come' as he was leaving the building, even though he appeared to be the last customer of the day.

There is a record of a craftsman being killed in an accident at the factory. Perhaps this is the unfortunate victim – he has returned to finish whatever task he was working on when his life came to an untimely end.

N

NEWCASTLE-UNDER-LYME

Milehouse Lane

During the summer of 1969, the world was still gazing up and marvelling at the landing of a man on the Moon. Three months later, in this corner of Staffordshire, nothing was further from the mind of six children playing in the early October evening sunshine.

Three of the group were the Scott sisters, twelve-year-old Janet, Jacqueline, who was one year younger, and Diana, who was just eight. Suddenly the half-dozen friends were aware of a figure crossing the playing area. Frozen with fright, they watched as a female figure wearing a flowing black cape approached the play area. Eleven-year-old Janice Meadon noticed the dark scarf covered the lower part of the woman's face. Janice also told of how, as the girls beat a hasty retreat to the accompaniment of their own piercing screams, the black clothes turned completely white, with the exception of the black boots.

A local resident, thirty-eight-year-old Jean Dale, was not surprised when she heard of the ghostly figure. Twelve months earlier, almost to the day, she had been working near a window when she had seen a woman in smart military uniform coming quickly up the path. She opened her front door to the visitor before she had had a chance to knock. However, there was nobody on the path and nowhere to go. The woman had quite simply disappeared.

Poolfields

Early March 1983 and the Hemmings family of St Mary's Drive were disappointed to receive a letter from the council declining their request for a move on the grounds that their home was haunted. A somewhat dubious spokesman for the council said such reasons would guarantee an escalation in the number of ghosts in council properties in Newcastle-under-Lyme.

Sidney, his wife Pauline, and their children Terry, Mark, Jane and Caroline had all experienced something of the ghost over the twelve years since they moved in.

More than thirty sightings of what was described as a 'white ghostly phenomena' prompted Mrs Hemmings to use a homemade Ouija board to question her tormentor. Contact was made quite quickly, with the messages coming from a teenage girl.

However, this did not stop the problems. Indeed, they escalated, and seemed to focus on the eldest son, seventeen-year-old Terry. He had taken to sleeping in a downstairs room and was stunned to see the figure of a girl approaching him as he lay there. His arm went numb and he could feel the sheets being tugged off. On another occasion he was physically attacked while asleep.

All the family had reported sensations of chilling cold in various parts of the house. At times the distinct aroma of hair lacquer was detected in the front room and hallway. The nauseous stench of 'something long dead' was highly disturbing. All this proved too much and the Hemmings were given the opportunity to spend the hours of darkness at a friend's house. Meanwhile an exorcist, summoned from Crewe, was asked to rid them of this problem.

It was not all bad news for the Hemmings. Within a week of the story reaching the newspapers, the council had offered alternative accommodation.

NORBURY

The Manor Estate
Built in the fifteenth century, Norbury Manor was the property of the Fitzherbert family until it was sold in 1881. Since 1987 it has been the property of the National Trust. However, it is not the main building that peaks our interest, but an old building in the grounds.

During the eighteenth century, several ghostly reports came from one building. There are no records of what was seen or heard, and nothing is known of those who reported the phenomena. We must assume the building had been vacated and empty for some time when it was demolished in the nineteenth century. The masonry was too good to be left lying around and thus it was soon used in the construction of a farmhouse just a hundred yards distant.

Not long after construction had ended, the building was occupied and working well. Apart from the usual farming activities, the occupants were also brewing their own beer, a common occurrence at the time. Before long, reports of footsteps were heard crossing empty rooms and unseen people were heard walking along passageways when there was nobody else in the place.

Most telling was the brewing equipment, which was laid out each night ready for the start of work the next day. While the residents were upstairs each night, their sleep was disturbed by the sounds and smells of the brewing processes apparently carrying on downstairs. That nobody investigated at night is understandable, but

when work started next day the brewing equipment was exactly as it had been left the previous evening.

Had the ghosts of the old building moved with the stone?

NORTON CANES

Kath

At the former Wilkin Inn – named after a family who owned land here – the ghost of a woman was purported to still reside. Tradition says her name was Kath, but there is no evidence to support this. She is said to have been hanged outside the premises and, while the old inn no longer exists, Kath seems to have found a new home at yet another premises open to the public.

What was known as the Fleur de Lys had been an eatery of some form for a number of years. For more than eight years there had been reports of a ghost smashing crockery. Yet it was not until 1985 – when manager Derek Lines distinctly heard someone call his name in a cellar that was otherwise empty – that the story was listened to more closely.

O

ONECOTE

Ride of Terror

Walking home from Leek market, a famer was tired and looking forward to reaching his home as night was falling fast.

Without warning, the man alarmingly found himself torn from the ground and, in one movement, whirled around and thrown into a saddle, behind a rider. Worse was to come. The farmer soon realised this was no ordinary horseman, for the rider had no head on his shoulders. Too shocked and dazed to react, all the farmer could do was hold on for his very life as the unworldly beast raced on through field after field, ripping through the hedgerows, crashing through trees, never slowing one iota. Eventually, close to his home, the man was thrown to the ground. Dazed, scratched, bruised, battered and maimed, he managed to claw his way to safety. Sadly, despite the rest and nursing from his family, the farmer died several days later.

Another man spotted the headless rider much later. He managed to escape the clutches of the dark spectre and live to tell the tale, however his horse and dog were not so lucky – within days both faithful animals were dead.

The locals were in a state of panic. Terrified they would be the next to be targeted by the headless horseman, they sought the protection of the Church. No less than seven clergymen were sent for to exorcise the ghost – a phantom with three possible origins: one of the four manifestations of evil cast out of heaven; a former pedlar who was murdered locally; or a knight killed in battle with the Scots.

Tradition has it that the clergymen failed in their attempt to exorcise the ghost. They claimed the horseman was fated to roam around here until the 'crack of doom' released him from his wanderings.

P

PENKHULL

The Views

In the early 1960s, the residents of the home known as The Views were fighting to save this historical building. The local council were in the process of obtaining a compulsory purchase order in order to develop the area.

By 1965 the property had been split and was now two homes. Miss Beatrice Smee and Mrs Beatrice Ann Townsend had lived here for up to twenty years. In order to protect their homes, the ladies had delved into the history of the region in order to show that it was of historical importance.

Prior to The Views being built, this place had been used by both the Saxons and the Normans. Archaeologists working in the gardens had found evidence from both eras, while documents showed Earl Algar had moved into a fortress here during the eleventh century. This would have been around the time his daughter was born. This girl grew to achieve even greater fame than any of her family, for she married Leofric, Earl of Merica, and is best known for her naked ride through the city of Coventry (something acknowledged as anecdotal).

The ladies' greatest hope lay in this being the birthplace of Sir Oliver Lodge, who was born in Penkhull in 1851. Sir Oliver lived to the age of eighty-nine. He was a physicist, inventor and writer whose direct descendants have followed in his footsteps. He lectured at Liverpool and Birmingham universities, explained radio waves, had a hand in the development of electric spark ignition for the internal combustion engine, was a member of the Fabian Society and lectured on economics.

It was also revealed that the place was not only haunted but that a curse had been placed on it some years previously. Even the wording of the curse was known: 'Whosoever damages this house will suffer. Whosoever wantonly destroys it will pay for it with his life or worse.' Surely the only thing worse than paying with one's life is being condemned to walk the earth as a ghost.

Previously workmen had been demolishing some old cottages here. The contract had not been an easy one to complete as it had been plagued by a catalogue of problems and bad luck. As a result they claimed the place was, in their words, 'jinxed'. Masonry would fall unexpectedly, while workmen who had been fit and healthy one minute were taken ill the next – and yet soon recovered upon leaving the site. No one wanted to return to the place again.

Responsibility for these events has never been established; indeed, the identities of the ghost and the author of the curse remain a mystery. However, it should be noted that among the forty published works of Sir Oliver Lodge were many thousands of words on life after death.

The Views was saved. It is a listed building, but no thanks to Lodge – it was home to one of the land's most famous footballers, Sir Stanley Matthews.

R

RUGELEY

Christina Collins

On 17 June 1839 a gruesome discovery was made in the Trent & Mersey Canal just outside Rugeley. A woman's body, still dripping blood, was pulled from the water and carried up Brindley's Bank via what would become known as the Bloody Steps, since they were stained red by the blood of the victim.

She was identified as Christina Collins and had been travelling from Liverpool to London to meet her new husband Robert, who had found work in the nation's capital and had sent word for his bride to join him. Christina had obtained passage on a barge, but, fuelled by drink, the boatmen had raped and then brutally murdered the young woman before dumping her mutilated body into the canal.

Three of the boatmen were eventually brought to justice. William Ellis was sentenced to be transported, while James Owen and George Thomas were hanged outside Stafford Gaol on 11 April 1840. Such was the interest in this case that mobile gallows were constructed, to be wheeled out before a watching crowd of 10,000.

A summer evening in 1939 saw two women walking along near the canal when they heard a sorrowful wailing. Looking up, they saw a pitiful figure of a man, his long black hair framing the saddest of faces. His clothing – a coat and shirt and knickerbockers – was without colour, although his feet were hidden, shrouded by a very out-of-place mist on this warm evening. As they watched, he drifted across the grass and through the railings around the waterworks.

Understandably shaken by what they had witnessed, they thought immediately of the murder of Christina Collins. Well aware they were close to where she was murdered, they discussed the possibility of a link as they made their way to St Augustine's churchyard and to the tombstone of the murder victim. Already on edge, one can only imaging the chills that must have run down their spines as they reached the tombstone and noticed the date – for it was then that the

'To the memory of Christina Collins Wife of Robert Collins London who having been most barbarously treated was found dead in the Canal in this Parish on June 17 1839 Aged 37 years this stone is erected by some Individuals of Parish of Rugeley in Commemoration of the End of this Unhappy Woman.'

women realised it was exactly a hundred years to the day since Christina Collins was murdered.

Both later agreed there was only one person they could have seen by the canal. This can only have been the forlorn figure of Robert Collins, still distraught and inconsolable a whole century after the murder of his bride.

The Bloody Steps are associated with the sight of a number of children wearing Victorian clothing. Like children everywhere, they are blissfully unaware of anyone or anything and are fully engrossed in their game. They are only seen as dusk is falling.

Maud Sheldrake

In 1906 it had been fifty long years since William Palmer had been executed outside Stafford Gaol in front of some 30,000 onlookers. Maud Sheldrake would have been unlikely to have heard of the Rugeley Poisoner, not least because she was not living near Rugeley but in Lutterworth. Of course this is not in Staffordshire but Leicestershire, however there can be no argument that this is a ghost associated with Staffordshire (for the full story of Palmer's downfall, see page 47).

It had been a long hard day for Maud Sheldrake. Wearily she climbed the stairs to her room with the jug of clean water she had drawn for herself in one hand and a candle in the other. Preparing for bed, she reflected on how lucky she had been to secure such a good position in the service of a local family as a teenager without previous experience. Her room was sparsely furnished but it was pleasant, light and airy – much better than many domestic servants of the day managed.

She poured water from the jug into the basin – the *en suite* of the day – and washed before slipping into her nightdress, extinguishing the candle, and feeling the shiver from the cool sheets as she snuggled down. She was tired and the bed was comfortable, but sleep would not come easily.

Maud was restless and tossed and turned until, for reasons unknown, she suddenly sat upright in bed. She was greeted by a sight that both amazed and shocked her. At the foot of her bed stood a man wearing white riding breeches, dark boots and a coat that, in the unusual light, appeared a shade of green. She watched as the man slowly seated himself in her only chair and then slowly faded from view. Understandably frightened out of her wits, the girl sent a message to her mother, who came to collect her daughter the very next day. She never returned to the cottage and its mysterious – and quite handsome – stranger.

It later came to light that this room had previously been slept in by no less than John Parsons Cook, victim of the Rugeley Poisoner in November 1855.

Vine Inn
Anne Lane came here as landlady in 1970 and remained for more than fifteen years. During the 1980s she spoke of how her family had been subjected to numerous visits from the resident ghost.

Nobody had any idea of the identity of this figure, although presumably it has some connection to the pub, which is thought to date from the seventeenth century. The figure gives no clues, for it only appears as a misty or shadowy form of a person and vanishes when challenged. Once it appeared at the foot of the landlady's bed but, true to form, immediately vanished when she demanded to know who was there and what they wanted.

Anne's family were less brave. Her daughter took to sleeping with a Bible to ward off the ghosts, while her son-in-law would not sleep upstairs but only on the couch in the living room.

People have always been reluctant to speak of the resident ghost. It is harmless and quiet, but it does seem to become more active when the subject is raised.

S

SEIGHFORD

Seighford Hall Hotel

It is difficult to say what the age of this impressive building is, for although the central core is fifteenth-century, considerable additions were made during the Victorian period.

What is certain is that in the early nineteenth century it was a private residence. The master of the house had taken on a governess to educate and see to the welfare of his children. However, it seems she was concentrating more on their father than on her charges; her unrequited love led to her taking her own life.

The rustling of her long dress can be heard bustling along the corridors, while she is said to appear at specific times – but only in room eight and only when children are staying in this room.

SHUGBOROUGH

The Green Stone

The name of the object is a little misleading, for it refers to a bell. However, few will hear a note from this instrument some 3 inches in height. The name describes what it was made from.

During a quest to find a mystical red stone known as the Eye of Fire, two researchers were keen to find the Green Stone, for it was a vital link in the trail leading to their eventual quarry. Both were said to adorn Excalibur, the famed sword of King Arthur. Following his death and departure to Avalon, the stones were preserved by the Knights Templar and thereafter passed on by various individuals and eventually hidden. Finding the Green Stone led them to the Eye of Fire, which they eventually discovered in a part of Norfolk. However, it is the earlier stage of the investigation that interests us.

The trail led them to Ranton Abbey and specifically to Ranton Lodge. This estate had been purchased by Lord Patrick Lichfield with a view to restoration. He had no idea of the story or the legends when he granted the researchers permission to examine the properties. When they entered the lodge, they found the bell – formerly the Green Stone – hidden inside the plaster walls of the building. Carefully recovering the precious bell from its hiding place, they were forced to beat a hasty retreat as heavy breathing was distinctly heard and the plaster began to fall from the ceiling above them.

Both items are today held in a secret location.

Knock Knock

In the 1980s, decorator John Smith was hired to put a fresh coat of paint around Shugborough's Great Hall. The last visitor of the summer season had come and gone weeks before, leaving Lord Lichfield's stately home free of potential interruptions. At least, that was the plan.

Working away, John was interrupted by a knock at the door. As he had not yet painted it, he called out that it was safe to enter. However, the door did not open. A second knock came and again John invited them to enter, only to hear the knock again and again. Putting down his paint and brush, he crossed to open the door as the knock came again. He opened the door and there was nobody there. This was to be repeated at least twice on different days.

John Smith mentioned the rather irritating knocks to staff and found that this was not the first time they had heard of it. It was said this was none other than Admiral Anson (1697–1762), an ancestor of Lord Lichfield, who is remembered for his circumnavigation of the globe, his role in the Seven Years' War, and for the changes he made to the Royal Navy during his tenure as First Lord of the Admiralty. Yet the painter insisted there was no way the famous mariner could have been knocking, for this was undoubtedly a knock from the hand of a lady of some breeding.

Lady Harriet

During the 1980s, reports of footsteps and rustling skirts alerted staff to an unseen presence. The ghostly woman was also cited as the cause of the gentle tapping on doors around the estate.

Thoughts as to the identity of this woman immediately turned to Lady Harriet, who had died during childbirth in the state bedroom, a room that has long been said to have a particular chill.

STAFFORD

The Ancient High House (I)

Look at any tourist brochure for the county town and this building will certainly feature prominently and rightly so. This is still the largest timber-framed town house in England, despite being over 400 years old. It was built in 1594 by the wealthy Dorrington family.

Charles I stayed here in the first months of the English Civil War, although it was subsequently used to hold Royalist prisoners. It was bought by the Sneyd family in the seventeenth century, and was owned by Brooke Crutchley in the eighteenth. The house had fallen into disrepair by the twentieth century and was closed for a while. It now houses an excellent museum of Stafford history.

Of course, a building of this age has its fair share of ghost stories. For example, there is a chair in the Stuart Room that makes its occupant feel irrationally apprehensive, even scared. Voices have been heard in rooms found to be empty, while doors have been both heard and seen to open and close by themselves. There are also stories of a young girl in the Victorian room accompanied by an old woman in a rocking chair, although nobody seems aware of whom they may be.

There is one known individual who is said to remain here years after his death: William Marson. His high-class grocer's shop occupied what is now the museum shop, although the entrance in those days was quite different. Today a false floor raises the level of the ground floor almost to the top of the original building's large fireplace. In Marson's day this large fireplace was adapted to serve as the main entrance to the grocer's shop, even though it was at the side of the building.

Marson was a lay preacher who had inherited his father's business, which was founded in 1827. Fifty years later, William Marson inherited the Ancient High House and ran his shop from the ground floor. He was well known for selling rare and unusual products from the East. Today there is a representation of the inside of Marson's establishment on the second floor, complete with a model of the man himself behind the counter. The image is quite accurate, having been modelled on a number of photographs. It was these photographs that enabled Marson to be identified when Stafford was visited by two American tourists during the 1960s.

At the time the building was quite unsafe and no visitors were allowed inside. Yet as the Americans approached, they were greeted by a man answering Marson's description who offered them a tour of the house. Together they were shown the many rooms on every floor of the house, including the impressive array of spices and fancy goods in William Marson's shop.

The next day these same Americans brought some friends to experience the same tour. They were met by the contractor and refused entry – it was far too dangerous to enter. When they insisted they had seen everything there not twenty-four hours

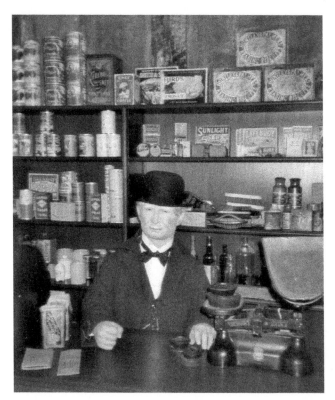

William Marson's image at the Ancient High House in Stafford.

earlier, adding a description of the man who had acted as guide, William Marson was recognised.

Does he still watch over this impressive building? If so – and knowing how much any of us loathe our own likeness – what does he make of the wax model in the mock-up of his shop in that upstairs room?

The Ancient High House (II)
Towards the end of the twentieth century, Stafford artist Ann-Jacqueline Bridge asked if she was the only person who had been speaking to the Grey Lady.

It seems the two women's paths had first crossed some five years earlier. Since then the two have conversed regularly and much of the former occupant's life has been revealed. The Grey Lady lived in the building itself, in an upstairs room, until her death somewhere between 1647 and 1666. She died in childbirth; tragically neither she nor her baby survived.

The Ancient High House (III)
A student lodging in 1964 saw a strange white shape in his bedroom. Rather than being worried by such, he saw it as a good omen and sought to benefit from it

in a most unusual way. Each week, prior to filling out his weekly football pools coupon, he called upon the resident ghost to lead his hand to place the crosses in the right places. In the following weeks he did indeed collect a couple of small wins. However, before long his spiritual assistant lost interest, and soon afterwards so did the student.

Church Lane

Near the church of St Mary is a supposed burial ground for medieval knights, although no archaeological evidence to support this has been found.

In 1915 a family in one of the houses here had been bothered for some weeks by odd crunching noises. No one could pinpoint the source of these sounds, which ended the same day the daughter of the household saw something that froze her to the spot at the bottom of the stairs.

She called out to her family and together they stood in astonished silence at the figure above them. At the top of the stairs stood a knight in full armour, wearing a long sword and carrying a shield adorned with a crimson cross. As they watched, the figure raised the visor to reveal two eyes inside the helmet. Indeed, they could only see the eyes, no face. As they watched, the figure vanished, never to return.

Of course, the shield featured a crest, a clue to naming the figure; sadly the image has never been identified.

Gatehouse Theatre

In 1995 the theatre put on a Halloween Spookathon, a charity event to raise money for Marie Curie Cancer Care. However, manager Gill Baker wondered if it had been a little *too* successful and had attracted interest from the other side.

The experience of one member of staff in particular was quite worrying. Having left her office, the woman was walking along the corridor when she heard a door slam behind here, followed by footsteps closing on her from behind. As the sound was almost upon her she turned, only to find she was completely alone.

Hall Close

In November 1969 a report came to light of a figure from the past appearing in the comparatively new flats here. A lady, dressed in a white robe, is said to have walked through doorways but only when the door was closed.

Most reports show ghosts are not troubled by modern access points. Indeed, reports often go to great lengths to point out that the spectre appears to have no perception of our world or those in it. However, the lady seems aware of the modern layout as she appears to actively seek out closed doorways.

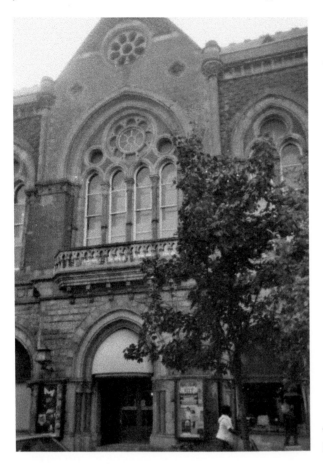

The Gatehouse Theatre building
in Stafford.

Horse Tale

This is one of several narratives from around Stafford Castle that could not have
been included in this book without the assistance of Jill Cox. The author's sincere
thanks go to Jill for her time and trouble in providing this information.

Stafford Castle was built in around 1090, originally a timber-and-earth
construction in the classic motte-and-bailey style. The mound took advantage of
a natural glacial deposit, with modifications in the form or banks and ditches still
visible around the 10-acre site. In 1347 Ralph de Stafford, the 1st Earl of Stafford,
began construction of the first stone castle. The importance of the castle grew until
the Wars of the Roses, when Humphrey Stafford switched sides. The family were
thus mistrusted by Henry VII, which was the beginning of the family's downfall.
While the Stafford estates were returned to the family, they were never to restore
their old importance.

In 1698, travel writer Celia Fiennes passed by, and commented on how the
ruined castle was overgrown. It remained that way for many years until what is

Right and below: Stafford Castle.

the present building took shape in the Gothic Revival style from 1813. The castle keep was a home until the mid-twentieth century, when the caretakers, Mr Stokes and his wife, were forced to move out owing to the building becoming unsafe. The removal of the mature woodland in the immediate post-war years probably contributed by exposing the building to high winds, resulting in masonry breaking away.

Some of the more mature residents of Stafford can recall the caretakers giving tours of the castle. The visitors were served tea and cake for the princely sum of thruppence. The couple had been here since before the Second World War and most likely knew more about the castle than anyone. Indeed, it has been suggested they were well aware of the phenomena witnessed by several over the years.

During the 1930s, a company representative lodged in the keep on a regular basis. Parking his car at the bottom of the drive – almost certainly where the visitor centre is located today – he continued up the slope of the drive on foot. As he came up the short walk he distinctly heard the sound of a horse galloping past. Even though the sound continued until he reached the castle, he could see nothing.

This experience greatly unnerved him and he was visibly shaken when he related the story to his temporary landlords. Yet Mr Stokes dismissed the incident and the representative would have accepted that he was mistaken had he not had the same thing happen again several months later. Again he reported the noise to Mr Stokes. Later he admitted that he felt the caretaker protested a little too much. Indeed, he went as far as suggesting Stokes may well have heard the sound but was keen to hide the truth from his wife so that she would not be frightened and leave their home.

In later years, the sound of galloping hooves has been reported by members of the public walking around the castle mound, although never has the horse and rider been seen.

Lily of the Valley

Another of Jill Cox's narratives from Stafford Castle will be familiar to anyone who has smelled the aroma of this late spring flower. It has a delightful scent, hence the reason for it once being a popular choice for a gentleman's buttonhole. Furthermore, the flower's perfume is rather distinctive, which is why it was strange to find this aroma being reported on many occasions by both visitors and staff.

The scent was always noted around the small flight of steps entering the courtyard – now closed off to the public for safety reasons. Oddly, while the flower is limited to a few short weeks in May or June, the ghostly aroma has been detected at many different times of the year.

Metalwork Memories

As reported by Stafford Castle's Jill Cox, an earlier member of staff may have reacted differently given the benefit of hindsight.

During the 1990s this member of staff was walking around the castle one afternoon when she heard the distinctive ringing sound of a hammer on a blacksmith's anvil. Nothing could be seen and she ran down to the comparative safety and company of her colleagues in the visitor centre. Visibly shaken, she described her experience and, with the support of her co-workers, quickly recovered.

Later she was angry with herself for not having the courage to stay and investigate the matter further. Perhaps she will never again have opportunity to witness a glimpse of history. This frustration was exacerbated when research unearthed an inventory from 1521, listing a blacksmith's forge in this very place.

St Lawrence's Church

Again thanks to Jill Cox of Stafford Castle for this offering, which took place 800 yards to the east of the castle. The church of St Lawrence was rebuilt in the Norman style in 1844, although the original church was much older. A gentleman was taking a walk through what was known as Castlefields towards the church, enjoying the last hour of a warm late evening in summer, when suddenly he was aware of a woman in front of him.

Dressed in what he described as Victorian attire, she was walking towards the stile. Astonishingly, she did not pause and climb the stile but passed straight through it and vanished on the other side.

Soup Kitchen

An eating house that dates from the sixteenth century, the Soup Kitchen was first mentioned under its present name in the census of 1871. The author was made extremely welcome by proprietor Duncan Sandy and the staff.

Any establishment of such an age is the inevitable location of a haunting or two. Here the blame has been pinned on the ghost affectionately known as 'Ethel', although one customer, who claimed to be a medium, said the visitor from the other side was male. Apparently the name of Ethel was given as the cloak the gent was wearing was mistaken for a dress.

Among the many little tricks played was the switching off of the oven before it reached the preset temperature. The switch is in a cupboard, so it is impossible to turn it off accidentally. The hot plate for the coffee – again, tucked away under the counter – has also been switched off. Once, at eleven in the morning, one of the busiest times of day, there was only cold coffee to serve.

Like many ghosts, Ethel is displeased by change, no matter how small or insignificant, and soon makes herself (or himself) known. Two cleaners each

The Soup Kitchen, Stafford.

thought they had heard the other working upstairs and thus did not clean there. However, it later became clear that neither had been there all morning and they were the only two in the building. Some have been fortunate enough to *see* the figure; indeed, one chef was so troubled by the experience he left soon afterwards.

Staff wash the dishes behind the area used for baking. One evening, when only the washing up remained, two members of staff heard a disturbance emanating from the baking area. On investigation, they found several plates spinning on the floor – which was rather perplexing as they were the only members of staff still on the premises.

The Soup Kitchen sells drinks to take away. These are sold in paper cups with a lid to prevent spillage. Both cups and lids are stored downstairs, ready for use. One evening two members of staff, the only two left on the premises, came upstairs to the staff room only to be bombarded by paper cups, thrown at them from a side room as they reached the top of the stairs.

The two employees were due to be picked up by one of their fathers, so they decided to vacate the premises and returned downstairs to await the lift. Their final task was to take the rubbish to the bins in the yard alongside the rear of the

Soup Kitchen. This included plastic containers and lids which, while they could be used, did build up and were periodically thrown away. As soon as they got outside, the sensor turned on the light to illuminate their way, which also allowed them to see the container lids being thrown at them. This was enough. They dropped what they were doing, grabbed their coats, and locked up. Neither of them had worked there for much more than a month and neither had heard of the ghostly reputation of the Soup Kitchen.

The next morning, Duncan Sandy was surprised to find the yard littered with lids. This was not typical of the staff, who were very reliable. However, when he heard of the previous evening's predicament he fully understood, as he did when one of the young men handed in his notice the next day.

Swan Hotel

During the seventeenth century this was the site of the college buildings serving St Mary's church. By 1711 there was an alehouse here, thought to have been named after the swan that featured in the coat of arms of Lord Stafford. From this time come stories of tunnels leading to St Mary's church and even as far as Stafford Castle.

As a coaching inn, the Swan was the place to stay in the town. However, when the railways brought more travellers than ever, the railway companies capitalised by building their own hotels right next to the station. Fortunately the advent of the motor car brought the custom back to the town centre and today the Swan is again the jewel in Stafford's crown.

Looking at the streets around here we find Mill Street, Mill Bank, Bridge Street and Water Street – indications that there was more water around here than just the river. It is rumoured that there was once a pool in Stafford – a macabre site where those who had been found guilty of witchcraft were killed by drowning.

During rebuilding work in the early twentieth century, a priest hole was discovered that would have been used during the Jacobite Rebellion. When investigated, it was found to contain numerous bottles and assorted bones, which proved a mystery impossible to unravel.

It was no mystery for the manager who lived here with his family in the 1940s and 1950s. Several times they reported seeing a female ghost who became known as the White Lady. During the 1970s she made another appearance before the then-manager, who found her standing beside his bed when he awoke with more than a little start.

Several reports since that time have her wandering the corridors, although as far as we are aware only one man was particularly perturbed. A chef who lived on site was so dismayed by the White Lady's presence that he left his job with immediate effect.

The Tunnel Spectre

Thanks again to Jill Fox of Stafford Castle for the following narrative.

What is known as the Tunnel actually lacks a roof – 'alley' is perhaps a better name. Dog owners have described how their pets stood, growling fiercely and with hairs bristling, refusing to go near this feature. One pet reacted just this way a few years ago, when Daryl Norton returned to the site after a gap of several years.

During the early 1990s, when Daryl was just fourteen years of age, he was cycling around the perimeter of the castle with friends. One member of the party, Neil, was forced to stop as his chain had come off. His friends waited for him near the castle entrance. A short while later, the repair complete, their friend came hurrying up to them at great speed.

Teenage boys are not known for their compassion and yet none ridiculed the sight of their friend shaking in terror, tears running down his face. Clearly he was greatly troubled and in a state of shock. In between the sobs they heard how, having finally struggled to get the chain back on, Neil had seen a shadowy figure in the trees to the side. Wearing what seemed to be period clothing, the figure did not move; it simply stood there and stared in Neil's direction.

The boys decided to report this and sought an adult. The nearest was in the castle shop. Far from thinking there was a prowler in the grounds, the man told the boys that several others had seen the same thing in the past. Furthermore, he described the figure exactly as Neil had to his friends minutes before.

A very similar experience was related by Daniel Lewis. A warm evening encouraged him and a friend to go for a stroll through the woodland around the castle and to rest and enjoy sandwiches in the shadow of the ruined masonry. After a few minutes a dark figure appeared to one side. Although startled, they said a polite 'Good evening.' There was no reply.

Disturbed by this menacing figure, they hastily packed up and within seconds were looking to see where the man was. There was no sign of him, nor indeed was there any indication that anyone had been standing there. For behind the fallen trunk of the tree the brambles were undisturbed. None of the nettles had been trampled or broken and not a footprint could be seen.

STOKE-ON-TRENT

Portmeirion Potteries

In May 1972 an extra employee was causing great concern among the largely female workers at Portmeirion Potteries. Although none of the management had witnessed anything untoward, works director Peter Chadwick was concerned enough to call in a medium in an attempt to alleviate the fears of the workers.

Many had heard ghostly footsteps in the oldest parts of the building, while some had also reported the ghost had a very nasty cough. Perhaps this cough was the link to another story from the factory's long history, for it is said a man hanged himself in what was the mould-making shop in the original layout of the building.

Lavinia Thompson and Doris Rowley were working in the warehouse when they both saw the misty form of a figure appear before their very eyes. This was not at night or when the factory was virtually empty but during the busiest time of the working day, when many were about and daylight was good. A third employee saw the same thing while working an evening shift.

Peter Chadwick kept an open mind when he called in medium Gordon Higginson, admitting he suspected this may be the work of a prankster. However he did hope the prankster would make himself (or herself) known, for he felt he could make better use of the time and energy expended by someone who seemed to be working twenty-four-hour shifts!

Sneyd Green

In July 1987 the local council were being bombarded with requests for a move by Michael and Wendy Banks. The young couple's home in Brocklehurst Way for the last two years seemed to be home to more than themselves, their fourteen-month-old daughter and newborn son.

Visitors eager to see the new baby had been plentiful during the last month. Yet many had felt uncomfortable and, like the Banks family, had reported a strange presence in the building. Furthermore, lights had been seen switching on and off entirely on their own, while curtains that had been closed at night were wide open when the couple awoke.

In the living room in particular the resident ghost seemed unhappy with the arrangement of the furniture. In the mornings the chairs and other furniture were found moved around time and time again. The sofa was a particular problem. It was often found behind the door, forcing Michael Banks to push his way into the room.

University Hospital

A very recent experience was related to me by a member of staff – a quite charming young lady whom we shall call Gabrielle.

The layout of hospitals was once universal. Cold corridors of brickwork painted in two colours, lighter at the top and darker beneath, echoed with footsteps on the tile floors. Off these led the larger wards, where rows of beds, each with its bedside cupboard, lined the walls. In stark contrast, today the open plan is favoured – a less regimented layout designed to make the patient feel more at ease.

Working the day shift, Gabrielle was walking along a ward where there were always a number of children. Ahead of her she saw a young girl, approximately

four years old, wearing a red coat. Otherwise she was quite unremarkable. She saw the girl turn into an office – the oncology office where Gabrielle herself was heading.

Standing in the doorway were three ladies, all members of the team. However, as Gabrielle looked around and started to ask about the young girl, it was clear there were only four people present. It was then she realised she must have seen a ghost. There was no other explanation.

For Gabrielle the experience was quite disarming. She had always rejected any suggestions of ghostly activity, indeed had very definitely been 'a non-believer'. She stood mouth agape and clearly shocked. Her colleagues found her a seat in the office and administered emergency treatment in the form of hot tea.

W. T. Copeland

In the middle of the eighteenth century, master potter Thomas Whieldon had two apprentices. The two young men would go on to achieve fame and their names are still familiar today – Josiah Wedgwood and Josiah Spode. It is Spode who is relevant to this story.

Josiah Spode set up his own factory in around 1770. It became Copeland & Garrett in 1843, W. T. Copeland in 1847 and Spode Ltd in 1970. The following reports refer to incidents that took place in early 1967, when the products were produced under the Copeland name.

In the glorious days of the 1960s, shortly after the England football team had lifted the World Cup, employees working late were enjoying a game of table tennis in the firm's canteen. Once upon a time many medium and large companies offered such facilities for their employees – sadly such is not the norm today.

Employee Bill Basford, who worked as an artist for the firm, volunteered to fetch a supply of new table tennis balls from the storeroom. This involved climbing the stairs in the old part of the factory. Knowing the new balls were just inside the door, Bill did not to bother to turn on the light but just pushed the door open and reached in to grab the box. Opening the door allowed a shaft of light to flood into the small room and illuminate a sight that made poor Bill freeze with terror. At the end of the room stood a man, leaning over his bench and painting. The man turned to look towards the door, revealing that his moustache was as white as his hair. Bill, thinking this simply could not be, found his legs to be working once more and turned and ran headlong down the stairs to the safety of his workmates.

On another day, director Harold Holdway and a colleague were working late when they heard footsteps approaching. Despite searching every room and corridor they found nothing. There was no exit through the room they were in and the opposite direction was bolted from the inside, so nobody could have gone out.

Who was the mysterious painter and why has he returned?

Izaak Walton's cottage
at Shallowford.

STONE

Miriam

Across the M6 from Stone is the tiny hamlet of Shallowford. The watery reference is appropriate, for here is the former home of Izaak Walton, author of *The Compleat Angler*, first published in 1653.

Walton's black-and-white thatched cottage is now a museum, a testimony to the man who is known as a fisherman but loved the countryside as a whole. This delightful building throws its doors open to the public for only limited times of the year. Any activity outside the normal opening hours seems to bother Miriam, the resident ghost here. Lights and electrical equipment turn on and off without warning, while her presence is almost always accompanied by a distinct drop in temperature. Why she is referred to as Miriam is a mystery; indeed the only reason for suggesting she is female is down to a psychic stating she is a busy lady.

There is a second, less well-documented presence that has not been named. However, there is no doubt as to his gender, for he has been seen walking through a hedge and following the line of an old path before vanishing from sight. He wears a costume dating to the seventeenth century. Perhaps, if not the man himself,

he is a friend and colleague of Izaak Walton. If so, he would be sure to have much information to add to the museum, although maybe this would further irritate Miriam.

St Michael's Churchyard

From the last years of the eighteenth century comes a story that will send a chill along most spines.

This narrative centres on Tom Meaykin, a young man whose twenty-one years were far too short a life. Born in a small village of the Staffordshire Moorlands, he left the village as soon as he was old enough to seek work in Stone. Fortune smiled upon him as he found employment with a local chemist, working as the houseboy and with responsibility for the family horses – meaning he was also a groom.

Life was good for Tom. Always smiling, he soon became a popular figure around Stone, yet it was back at the chemist's that his greatest admirer could be found. His employer's daughter was unashamedly head-over-heels in love with the handsome young man. However, they were from very different backgrounds, so any suggestion of an alliance was taboo, as the groom well understood. Yet this did not deter the pretty young woman and she often made her intentions known to Tom. Indeed, so little did she try to hide her feelings that it was inevitable that her father, Tom's employer, soon became aware of what was happening.

Predictably the chemist was furious, particularly so when he discovered how amused the people of Stone were by his daughter's antics. He confronted her and forbade her to continue pursuing Tom, yet she made it clear she would disobey him. On reflection, Tom's death shortly afterwards should have been eyed with suspicion, however this was a time when the life expectancy of males was only an average of some forty years and unexpected deaths were the norm.

After Tom's burial in St Michael's, reports came that his ghost had been seen walking the churchyard. Later, a horse managed to escape from the stables where Tom had worked, only to make his way, unaided, to the grave of the former groom, where he pawed at the ground. This was enough for the superstitious folk of the time to suspect something was amiss, and little more than a year after his death the family were asking that Tom's coffin be exhumed and the body examined.

When the coffin was opened, they beheld a terrible and telling sight. Tom's body was found face-down in the coffin and there were many scratches on the inside of the lid, proving he had been buried alive. Misdiagnosed as dead, he had in fact been in a deep coma.

Suspicion soon fell on the chemist. He had the knowledge, the means and the motive to have administered the drug that would have induced the appearance of death. No wonder Tom Meaykin's ghost could not find peace in the churchyard. Had the chemist used the skills of his trade to fake his employee's death? If so, the

justice system of the day lacked the techniques and technologies to prove his guilt and no charges were levelled against the chemist or anyone else.

The family were granted the right to bury the young man in his home village of Rushton Spencer. In order to prevent his ghost returning to haunt the place of his birth, he was buried the wrong way around, with feet toward the west and the head to the rising sun.

Tesco

This supermarket was built on the site of the former Black Horse public house. However, as far as anyone can recall there was no paranormal activity at the pub. Yet in 1977 staff at the food chain were so accustomed to the visits they had even given their ghostly visitor a nickname – Charlie.

Not every report is the same. Charlie seems to manifest himself in several ways. The first indication something was amiss was when boxes were sent crashing from the shelves in the storeroom. This was soon followed by taps on the shoulders of staff who, no matter how quickly they spun around, found they were completely alone. The then-manager, Tony Simms, had heard footsteps in the empty stockroom area. Later, a member of staff found Simms to report that 'a sales rep' had been found in that same stockroom – somewhere where only Tesco staff were allowed. The rep had said he was awaiting the manager, yet Mr Simms arrived to find it completely empty.

It was when Charlie turned his ghostly attention to the day's takings that things got really eerie. Mysteriously the coins, which had been left in the tills, were found in neat piles ready for bagging. Later, as the money was carried out of the building to be deposited at the bank, someone was clearly heard to be hitting the bag.

T

TAMWORTH

Bank House
This building on Lady Bank, the site of Tamworth's mint, once had a ghostly lady not connected with the name of the street.

A woman wearing clothes from a bygone age was seen feeling along what are now stone walls, as if trying to find an exit that is no longer there. This occurred more than once until, when new owners made structural changes to the building, the woman may have finally made her way out of Bank House.

The Black Lady
The story of the Black Lady was investigated by a paranormal group in 1949. Under the guidance of a Mr Quartermain, the group entered the haunted room of Tamworth Castle and checked that every door and window was closed and locked. Then the investigators were tied to each other and cameras were set up to cover all possible angles. Despite these efforts, not a clue was found.

However, the haunted room, on the first floor above the great hall, has been described by many of the visitors to the castle as 'icy cold'. Entering the room today, the visitor breaks a magic eye, which dims the lights and starts a representation of St Editha's original ghostly visit to the lord of the manor.

Tamworth's principal church is one of two in the borough dedicated to St Editha. The woman herself founded a convent within the walls of the castle during the tenth century. She and her nuns aided the townsfolk as they defended themselves against the last of the Danish raids.

When the Normans arrived in the latter half of the eleventh century, the nuns were evicted and sent to Polesworth, just across the border in Warwickshire, where Editha's aunt had been head of the abbey. However, this was land also held by the same Lord Marmion who had evicted them from Tamworth, and they soon found themselves ousted once more. This time they moved still further east to Oldbury, near Nuneaton.

Back in Tamworth, Lord Marmion had made improvements to his castle. One night, following a most sumptuous meal, he made his weary yet contented way to bed. That night he was awoken by St Editha, who was identifiable by the grey habit and veil of her order, and the crozier that was the staff of the office of an abbess. Editha's message was loud and clear, her anger obvious; she threatened that he would be made lame and then die unless he allow the nuns to return to the abbey.

Lord Marmion scoffed at her feeble threats and returned to his slumbers. However, the next morning he awoke to find he was bleeding from a wound on his leg where the abbess had touched him with her crozier. Furthermore, he was unable to walk – just as Editha had said. Instantly he changed his mind. He ordered that the nuns be allowed to return and, just to be sure, endowed the order with rich adjoining lands. Lord Marmion recovered and, while Editha was presumably appeased, she is thought to return from time to time in order to keep an eye on the castle and the abbey.

This traditional tale deals with the first Norman at the castle, the first Lord Marmion. However, history records it was the third of this line who returned the rights of Polesworth to the nuns and granted them the lands thereabouts in 1139.

Co-op Milk Bar

One of Colehill's most familiar sights for many years is a place where generations relaxed and enjoyed more than just milk. However, it is to the hairdresser's above that we turn our attention.

This building stands on the site of the home of William McGregor, probably the greatest Tamworth benefactor of recent times. He is commemorated in the names of a road and a school. A Scot by birth, he came south to make his fortune in Birmingham as a draper. It was there he found his one true love, Aston Villa Football Club, and he served as director, president and chairman over a period of twenty years. He was instrumental in meeting with the representatives of the other leading clubs of the day, which resulted in the formation of the Football League, the world's first.

Staff at the hairdresser's in Colehill regularly heard the chuckle of a man. Was this an echo of the man who did so much for his adopted town and his beloved football club?

Daddy Poppit

The short street known as Colehill was home to an old building. Here in the nineteenth century were a pawnbroker's premises, owned by an old miser known as Daddy Poppit. His business earned him a fortune, of which he spent as little as possible.

Following his death, the pawnshop closed and became a dental surgery. Having amassed his fortune he was unable to take it with him. Thus he returned to his former premises and, in his anger and frustration, threw the dentist's instruments around the room.

Moat House

There cannot be any mention of Tamworth's past without a reference to the Moat House. Sitting on the banks of the River Tame, it was built in the sixteenth century by William Comberford.

There are two purported entities here. One appeared to a young girl in the garden near the gazebo. The girl said the ghost was wearing a grey cloak. Others in the grounds at the time saw the girl chatting away, but she appeared to be alone.

The second ghostly report comes from inside the building. Here, on the first floor, is where a girl called Emily is said to roam. Tradition has it that she was trapped in a room in the upper part of the house. Her father had inadvertently locked her in and she died as a result of a fire started by a candle.

Moat House, Tamworth.

Rawlett School

On his death in 1686 the Revd John Rawlett bequeathed monies to provide a school, a library and various charities to Tamworth. Rawlett was an understated benefactor of the town, most unlike Thomas Guy, who represented Tamworth in Parliament. Guy's name is commemorated by the town hall, the almshouses and, most famously, Guy's Hospital in London. Both men were fellow pupils in Tamworth and would have been well acquainted in life.

Rawlett would not recognise the school that bears his name on Comberford Road. However, two pupils recognised the school's founder when, more than three centuries after his death, he was seen roaming the corridors.

The White Lady

The White Lady is one of the two most famous ghosts said to walk the ancient site of Tamworth Castle. The present building has Norman origins, although there was a Saxon construction here from the early tenth century.

Sir Tarquin is said to have brought this married lady to the castle against her will. However, stories of her being locked in the tower are somewhat fanciful, for Tamworth Castle has never had a tower. As the days of her incarceration passed, her feelings for her captor changed and she soon realised she was deeply in love with this man – who, we must assume, had brought her to his home in order to win her heart.

One day she was watching her love as he showed off his fighting skills in a tournament held on Lady's Meadow – the area on the other side of the River Tame, alongside the present Lady Bridge. Imagine her horror as she watched the new love of her life collapse and die when competing against Sir Lancelot du Lac, the famed knight associated with King Arthur who is best known, somewhat ironically, for his affair with Queen Guinevere.

As this was a tournament, his death is presumed to have been accident. However this did not mean she mourned her lover any less. Since that day, the wails of the grief-stricken woman are said to be heard around the castle mound, and there are frequent reports of her ghostly form walking the battlements.

Visitors to the castle should keep an eye out as they cross between the chapel and the room now set aside as the town's museum, for these narrow battlements are where the White Lady has been seen.

Working at the Castle

Tamworth Castle is an ancient building and has been through many phases of building and additions. It comes as no surprise to find that when the last visitor has left and the doors have been locked, the silence is broken by any number of noises. For the most part the staff are used to these sounds and yet sometimes they are perceived as being anything but random.

One such occasion saw no less than three members of staff standing in the doorway to the main courtyard shortly after the last visitor had left the building. Suddenly they were aware of footsteps coming from within the building, clearly female and crossing the wooden floor of the great hall. Thinking a visitor had inadvertently been locked in, they went to investigate, yet found nobody. Suspicious that the individual may not wish to be found, they started a thorough search while another member of staff searched through the recordings of two CCTV cameras. Around the time the footsteps had been heard, the great hall had been completely empty.

On another occasion, the building was completely empty and had been securely locked. As happens from time to time, the alarm system was tripped and the police and duty key holder were summoned. A thorough search of the castle revealed nothing, but they could not lock up until an engineer from the company that had installed the alarm system had checked the installation. Clearly it is important to ensure the alarm is working correctly – a faulty system may repeatedly raise an alarm and waste the time (not to mention test the patience) of both police and key holder.

The engineer arrived and was soon checking the equipment. Within what seemed little more than a few moments, he returned to report that all was working correctly.

'That was quick!' retorted the duty member of staff.

'There was a woman in the room above,' responded the engineer. 'A woman was watching so I got out quickly.'

The description did not match either of the regular female ghosts of Tamworth Castle. Does this famous Tamworth landmark have a third lady from its illustrious past watching over the present?

TIXALL

The Gatehouse

Built in around 1580 by Sir Walter Aston – the son of Sir Edward Aston, who had had Tixall Hall built twenty-five years earlier – the Gatehouse is connected by walls to the main building and forms an enclosed Elizabeth courtyard. It is a major building in its own right.

Three storeys rise to 50 feet, with a flat roof surrounded by a balustrade and two octagonal towers at each end adding another 10 feet. The Gatehouse is topped by domed roofs and weather vanes. Either side of the central archway are porters' lodges, with upper storeys providing accommodation for the steward of the estate and also temporary accommodation for guests.

Two of the guests at the Gatehouse probably later wished they had never seen the place. In 1678 Lord Stafford was arrested here, having recently returned

from Europe. A staunch Royalist and Roman Catholic, he was implicated in the infamous Popish Plot, an anti-Catholic fabrication led by Titus Oates alleging a plan to assassinate Charles II. Along with four other Catholic peers, Stafford was imprisoned in the Tower of London. The trial was delayed as it seemed certain the five would be released. However, when anti-Catholic feelings grew again in 1680, the men were sent for trial. Stafford was beheaded on Tower Hill on 29 December; in 1929 he was beatified by Pope Pius XI.

A century earlier, an even more famous figure was brought to the Gatehouse. In 1586, Mary, Queen of Scots, was brought here; her luggage was taken to Chartley Castle to be searched. She was kept here for two weeks while a complex web of intrigue saw her implicated in a supposed plot against Elizabeth I. Forged letters were planted in the belongings. She was taken to Chartley and events were set in motion that led to her eventual execution.

Neither deserved their eventual punishment – that is certain. Perhaps that is the reason the sound of a mournful tolling bell has been heard within the Gatehouse but nowhere else nearby. No such bell is to be found.

TUTBURY

Tutbury Castle
A confused jumble of sightings here, including Mary Queen of Scots, a monk in brown robes, a grey lady, a little girl called Ellie in the king's bedroom, and a gentleman in armour, who is wont to demand of all and sundry, 'Get thee hence!'

The first castle was built in the eleventh century and was largely destroyed by Prince Edward in 1264. Rebuilt in the fourteenth and fifteenth centuries, it provided one of the prisons of Mary, Queen of Scots, in the sixteenth century and is largely a ruin today.

The drummer boy is the most regularly reported ghost; he is purported to be a good omen. The sound of the warning drums comes from the north tower. An echo of a time when the castle was under attack, the drums were once sounded to warn the guard. Sadly they were not quick enough to save the poor boy who had drawn their attention to the danger. A single arrow to the head killed him, bringing the drumming to an abrupt stop.

W

WALL

Romans Remain

The Roman station at Wall is an interesting site north of the former Roman road of Watling Street. The remains are only the foundations, although the views afforded by the higher ground at the nearby churchyard are excellent. At this point, Watling Street (today designated the A5 trunk road) is separated by little more than a hedgerow from the M6 toll road.

It was a bright afternoon in December 2005 when Sue Cowley paid the requisite toll charge to travel along the road that had opened almost two years ago to the day. Ahead of her she saw the shadowy figures of what she first thought were livestock animals crossing the three-lane highway ahead. As she slowed, she realised these were not animals but men. Nearer still, she was in real danger of colliding with them, and so she came to a stop.

Sue could not believe her eyes, for passing in front of her were what appeared to be 'upright shadows'. Some twenty or so men, the silhouettes of Roman infantry, were crossing the road and walking north. The bottom part of their legs was missing, and they appeared to be wading through the tarmac as if it were shallow water.

Over thousands of years, the level of the land rises – hence the reason archaeologists find the distant past buried deeper. 2,000 years ago, the level of the land would indeed have been lower than it is today, so perhaps it was at this level that the soldiers were walking.

WEEPING CROSS

Baswich House

Our story starts in 1813, when thirty-eight-year-old John Stevenson Salt purchased the Weeping Cross Inn at auction. He modified it to create a second home for his family,

then resident in London. He and his wife Sarah had no less than twelve children. The eldest, Thomas, inherited the old inn and built a new house, which he called Weeping Cross House. By 1906, Sir Thomas Anderdon Salt was the owner; he sold the property to one William Morton Philips, who was to remain here for nine more years.

In August 1915 the property was sold again, George F. A. Osborn purchased the building, which was renamed Baswich House. It was then that it was used as a boys' preparatory school, which closed in July 1940 under the ownership of James M. Brown.

During the dark days of the Second World War, the pupils and staff of Ramsgate's Clarendon Girls' High School were evacuated to the safety of Staffordshire. At this time, three rooms on the first floor were utilised by the ARP wardens, with fire watchers housed in the cramped conditions afforded by the Anderson shelter in the grounds. Following the end of the war, new legislation governing building projects meant new owners Joules Brewery were unable to turn the place into a hotel, thus Stafford Borough Council used the place as flats for their employees for a couple of years until it was sold yet again.

In 1952 the building and grounds were purchased and became a motor training centre for the police force. By the following decade, the grounds were being developed to house the headquarters of the county's police force. However, in 2002 the daily hustle and bustle had moved out and Baswich House became home to the Police Museum until 2007, when the collection was shared between the many other museums in Staffordshire.

Baswich House was now empty for the first time in its 150-year history. That history ended, somewhat controversially, in March 2009, when it was demolished. Plans to develop the area have still to be resolved at the time of writing.

At various times during the life of Baswich House there had been reports of doors mysteriously opening and closing with no apparent reason. Such phenomena are usually associated with change or call attention to someone or something. Without any knowledge of the times and dates of the doors that moved themselves it is difficult to hazard even the smallest guess as to why this should have occurred.

It is quite possible that the ghosts were inherited by Baswich House from the earlier Weeping Cross Inn. Indeed, the name of Weeping Cross itself could be a clue to the unexplained events of the twentieth century. As a place name it is not unique, although other 'weeping crosses' are little more than small fields or a marker at a junction.

Prior to the Reformation, a network of crosses were erected across the country, placed there as memorials to loved ones. They were a magnet for travellers away from their usual place of worship. For some they symbolised penance. Used until the late nineteenth century, the term 'to go home by the weeping cross' meant to do something one would later rue.

Baswich House, Weeping Cross.

Perhaps the weeping cross and the door problems of Baswich House are connected. Maybe the answer will be found should the land be built on again and the strange events return.

WESTON

Weston Hall

Like many large houses, there are several stages of building at Weston Hall as successive owners stamped their individual mark on their cherished home. In this case, documented evidence is patchy – indeed there is nothing of the earliest history of the hall.

Architecturally, the oldest part is certainly the main body of the hall, which is clearly Elizabethan. Traditionally this is believed to have been built as a dower

house, a property built specifically for the widow of the late owner of the estate when it passed to a new owner. While we have no idea who these early occupants or builders may have been, we do know an extension in 1660 created the high-pitched roofs and three gables that give the hall its distinctive silhouette.

By 1666, the year of the Great Fire of London, the Hearth Tax Assessment lists a building in Weston as being levied for its eleven hearths. While the building is not named, it seems impossible that that was not Weston Hall – otherwise there would have had to be another large building (which is completely unknown) or else Weston Hall was missed completely or had a maximum of two hearths. At that time the owner of that house was Abraham Fowler, a member of a family whose wealth was derived from their ironmongery in Stafford. In the late seventeenth century the Fowlers sold their properties to the Chetwynds of Ingestre; Weston Hall was most likely on this list of purchases.

The end of the nineteenth century saw the arrival of new owners, the Shrewsbury Settled Estates. Further extensions were built in the Elizabethan style, which blended perfectly with the existing architecture. In 1904 Weston Hall was rented by Staffordshire County Council as an asylum and forty years later the British Army requisitioned the property during the Second World War. The Godwin family purchased the hall in 1950, turning it into flats. It lay empty and in poor condition until it was converted into a restaurant and hotel from 2001, courtesy of Stafford businessman Paul Reynolds. When he purchased the property it was very run-down and work took nine years to complete. Many of the original features were preserved in the oak beams, mullioned windows and stone fireplaces.

It comes as no surprise to find this place has had its fair share of non-paying guests. And Weston Hall's reputation for the paranormal is not just from the modern era – during the Second World War, the ATS girls refused to sleep inside this Gothic-looking mansion, preferring to spend the nights in tents in the grounds. Villagers have been treated to the tales of the Grey Lady, said to wander the lanes and fields around the hall, ever since they were born. However, the author was unable to trace a single documented sighting.

Routine maintenance was necessary during the 1970s, 1980s and early 1990s. Workmen contracted to carry out vital repairs – essentially to prevent the building collapsing – refused to enter the building alone. Yet it was when the building was reopened at the end of the twentieth century that reports increased.

Only days after the reopening, the cleaning staff came to work each morning to find the bar area had already been cleaned. When someone suggested this was the work of a tidy-minded prankster it was pointed out that security cameras and alarm systems had not detected anything. Other staff heard the softly whispered voices of unseen women calling them by name (although it should be noted that nobody has ever heard their name while experiencing the phenomenon with a

Weston Hall.

companion). Some have heard a delightful melody played on a piano – not a recent piece but one that belongs to a much early period; it is not recognised by anyone.

However, the most inexplicable event happened in the early hours of the morning, when staff and wedding guests were winding down after the wedding celebrations. Many had their attention drawn to the sound of horses pulling a carriage up the drive, whereupon it stopped and there was the sound of feet landing on the gravel. It was easy to imagine this as the coach and horses drawing up to the house and the footmen dismounting. The most difficult problem here was not that they could not see anything, but rather the distinctive sound of the wheels, hooves and feet on the gravel path –the driveway is completely covered by tarmac.

WHITMORE

Whitmore Hall
The Mainwaring family came to Whitmore in the sixteenth century, when Edward Mainwaring of Biddulph married the Whitmore heiress, Alice Boghay. Their descendants included five Edward Mainwarings, who all served as High Sheriff of Staffordshire in a period of just over a century from 1645 and 1767.

The stables at Whitmore Hall.

The family can trace their ancestry much further. Indeed, as a family tree hanging in the entrance hall shows, they can proudly trace a direct line to William the Conqueror. Around the home, family portraits show an unbroken succession of residents from 1624, although very few are dated and it has taken a fair amount of detective work to fit them into the history of the place. The house has remained in the family since the sixteenth century, apart from a period between 1863 and 1920 when it was leased. One of the tenants was pottery manufacturer Thomas Twyford, who lived here for some thirty years.

Over the last few decades the house has undergone some refurbishment and several important features were uncovered. Removing the plaster revealed the walls of a timber-framed building perfectly preserved within the framework of the present building.

Dendrodating experts were called in and core samples taken. Analysis showed there were two quite distinct dates. The wood of the later walls, showing a distinctly red colouring, was cut in 1776. There were also remnants of a fifteenth-century building here, but the exact date proved difficult to trace, with few rings to go by. It has since been realised that all three houses are effectively intact – Whitmore Hall is a house *within* a house *within* the present Carolean-style architecture.

Whitmore Hall.

Outside there are early seventeenth-century stables, a very rare example of a late Elizabethan stable block with nine stalls and a partially cobbled ground floor. Each stall is carved from oak and divided by Tuscan pillars and most impressive arches.

When the author was treated to a tour of this delightfully bright and attractive home by Captain and Mrs Cavenagh-Mainwaring, the stories of two resident ghosts were retold. The first is said to linger in the stables, which, for all the ornate designs, certainly have a most ominous feeling within. This is particularly prevalent on the upper floor of the stables, where blackened beams are reminders of the terrible fire that trapped a young stable boy. His desperate cries for help are said to have been heard.

Walking through the gardens, with the lake and waterfall and a maze planted in 1842, we are reminded that this is held to be an early creation of the most famous of landscape gardeners, Lancelot 'Capability' Brown. Arriving at the main house we find another apparition resides within, but this time there is no ill-feeling – on the contrary, the house and its musical ghost seem to draw visitors to this corner of Staffordshire.

In the entrance hall are several paintings, one of which proves to be of particular interest. This is the image of one Sarah Bunbury, who, as the painting states, was the daughter of William Bunbury. Little was known about this fresh-faced young

lady with the pleasing countenance and engaging smile until one day in the late twentieth century, when a visitor came to Whitmore.

It was a time of change. The major refurbishment of 1995 had brought life back to this Grade I-listed building, and the Cavenagh-Mainwarings had become grandparents, courtesy of the twins their daughter had just brought into the world. Indeed, the babies were staying at the hall when an old friend came to visit their mother. She proved to be a most interesting guest.

The woman was particularly proud of her abilities as a diviner. She was asked by the lady of the house to give her impressions of what she thought might be here. After a few moments she came out with a date, exclaiming, '1798, she says she died in 1798.' Immediately Mrs Cavenagh-Mainwaring remembered a book she had been perusing less than two days before and went to retrieve it. Quickly finding the relevant page, she reported that one Sarah Bunbury had died in 1798. She then proceeded to tell the diviner about those, including herself, who had heard the faint sound of music playing. None had managed to make out the tune, yet all had said the music was coming from someone playing the harpsichord. 'Not a harpsichord,' responded the visitor. 'She says it's a clavichord.' The clavichord and harpsichord are similar, but the former was for the home rather than for public performance.

Mrs Cavenagh-Mainwaring asked if she knew why Sarah Bunbury had returned to the hall to play the clavichord. 'The children,' replied the diviner. 'This is the first time for 150 years that children had been in the home and she likes children.'

Not all ghosts are harbingers of gloom and doom.

WHITTINGTON

Whittington Inn

This timber-framed building was constructed in 1310 by Sir William de Whittington. While his fame was limited, this was not true of his grandson Dick Whittington, whose story has been told many items and is a favourite of the pantomime season. He was no pauper – he was a landed gentleman of a most prosperous and powerful family. He certainly became Lord Mayor of London three times and may well have owned a cat.

Others famous figures associated with the Whittington Inn include Charles II. During his long flight from the Battle of Worcester he is said to have hidden in a priest hole here. The inn can also claim a link to Lady Jane Grey, whose reign – and many still refuse to acknowledge it as a reign – lasted just nine days or thirteen days depending upon whether one takes the proclamation or the death of her predecessor as the start date.

The tragic story of Lady Jane Grey was once staple fodder of the school history lesson. Today the onus is more on the political intrigue behind the scenes, rather

than the young woman herself. Jane Grey was the great-niece of Henry VIII and the eldest granddaughter of Mary Tudor. Despite being only seventeen at the time of her death, she was certainly one of the most learned women of her day and was an excellent choice to follow Edward VI.

Jane Grey came to the Tower of London in July 1653, shortly before her proclamation as queen. She never left and was executed there on 12 February 1654. Her death was ordered because of her family's involvement in Wyatt's Rebellion.

There are conflicting reports associating Jane with the Whittington Inn. Whether she actually visited the inn is uncertain. Indeed, if the reports of her ghostly appearances nationwide are to be accepted, she seems to be far more travelled in death than she could ever have hoped to achieve in her short lifetime. There is no record of an actual sighting of the tragic queen, nor any suggestion of why she should be cited as being in residence.

This is not the case with Richard (or Dick) Whittington, thrice Lord Mayor of London, whose family owned this house and its estate. Not being the eldest son, he was not going to inherit, and thus he went to London and learned the trade of a mercer. He was successful and showed a good profit, including that earned by selling cloth to Richard II which amounted to a total of £3,500 –£1.5 million in today's terms. Thereafter he entered moneylending, including great sums of money to the king. Around the age of thirty he became a councilman, first at Nottingham and soon after in the capital.

As with Jane Grey, no recorded sightings of the most famous (or indeed any other) member of the Whittington family have been recorded. Perhaps both have been suggested by a medium – the usual way a name is given to a presence. However, there have been two other ghosts, one of whom – the ubiquitous ghostly monk – has been seen roaming both premises and grounds. Another is less appealing – an unknown spirit whose very male hands have been felt around the throats of guests who have stayed here. It should be added that no lasting harm has ever come to anyone.

When the author visited the pub and restaurant neither Queen Jane nor Lord Mayor Whittington offered an interview. No monk paused for a photograph, nor, thankfully, were hands placed around his throat. However, a customer in one room, ignorant of the presence of a writer seeking a ghostly story, was keen to quaff his drink as quickly as possible and leave the premises. He could offer no plausible reason for feeling so ill at ease, yet insisted there was something unnerving in the place. There was a very definite chill; he was sure he was being watched.

However, he seemed more perturbed that nobody else could sense these problems than by the chills and unseen stares.

WOODSEAVES

Birmingham & Liverpool Canal

Opened in 1835, this narrow stretch of the British canal network connected the Chester Canal at Nantwich to the Staffordshire & Worcestershire Canal near Wolverhampton. This canal was built by the famous engineer Thomas Telford. It is 39 miles in length, has twenty-six locks and drops 176 feet. It brought goods from the Midlands to the port of Liverpool. It continued to carry goods until the mid-1960s, quite late for an inland canal in this country.

Our narrative comes from 1879, specifically the night of 21 January. It was a cold night, well lit by moonlight, and a man was driving his horse and cart from Shropshire to Ranton when he crossed the bridge across the canal here. Before he reached the other side, a fearsome sight leapt from the trees onto the back of his horse, which bolted.

On the back of the horse was a terrifying sight. An impossibly black creature with huge glowing eyes that appeared to be half-man and half-monkey was whipping the horse to ever greater speed. The driver fought back, thrashing wildly with his whip, trying to hit the creature and yet avoid inflicting further woes upon his horse. On more than one occasion the leather whip found its mark, yet it passed straight through the beast. The battle continued until the creature vanished into thin air.

Folklore tells of a man who killed himself here. Suicides were denied a burial in consecrated ground, hence these tortured souls were blamed for many unexplained events.

The bridge over the Birmingham & Liverpool Canal.

Y

YOXALL

Blacksmith's Apprentice
A local blacksmith had a reputation for not being the most pleasant of individuals. The demands on a blacksmith could be of sizeable proportions, and this man's mood swings would have made him seem extremely frightening.

Working alongside him, the blacksmith's apprentice would clearly have been the easiest target for his foul temper. It seems the poor lad was so badly mistreated by his master that he eventually took his own life. As suicides were denied a Christian burial in consecrated ground, they were most often interred near a crossroads. However, Yoxall has no crossroads as such, so the most likely position is around Victoria Street, near the sharp bend in Main Street and opposite the church. It is said that any horse will refuse to pass near the spot.

There is a second story that shares many elements with that of the dead apprentice. This time the body of a youth was placed inside a tumulus. His death was the result of one or more spears, depending upon the version told. Again the spot is where no horse will pass.

BIBLIOGRAPHY

BOOKS

Bell, David, *Ghosts & Legends of Staffordshire and the Black Country*.
Berkswich History Society, *They Pulled Our House Down*.
Blundell, Nigel, and Roger Boar, *The World's Greatest Ghosts*.
Brighton, Revd F., *A Tale of Ipstones*.
Clowes, William, *The Journals of William Clowes: A Primitive Methodist Preacher*.
Pickford, Doug, *Staffordshire: Its Magic and Mystery*.
Poulton-Smith, Anthony, *Black Country Ghosts*.
Rae-Ellis, Vivienne, *True Ghost Stories of Our Time*.
Raven, Jon, *The Folklore of Staffordshire*.
Whitaker, T., *England's Ghostly Heritage*.

NEWSPAPERS

Tamworth Herald
The Sentinel
Burton Mail
Express & Star
The Post
Evening Sentinel
Weekly Sentinel
Chronicle
Stafford Post
Cannock Chase Chronicle
Rugeley Times
Cannock Chase Post

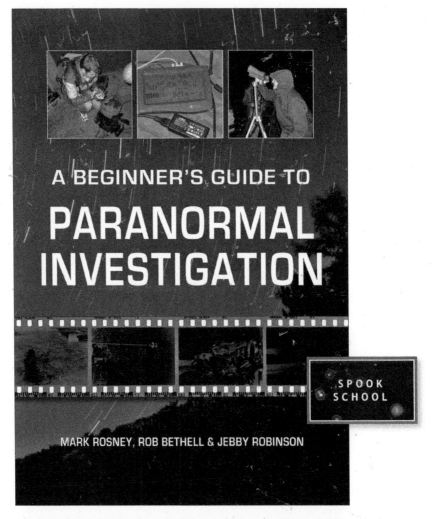

A BEGINNER'S GUIDE TO PARANORMAL INVESTIGATION
MARK ROSNEY, ROB BETHELL & JEBBY ROBINSON

Aimed at the complete beginner, this book shows you what you need to know in order to conduct effective paranormal investigations – from assembling your basic kit through to revealing useful methods and techniques that will help you to conduct effective investigations in a no-nonsense manner. Since paranormal investigation can be a costly pastime, this book also shows you how to investigate on a shoestring budget.

Written by the members of Para-Projects – three experienced paranormal investigators with over thirty collective years' investigation experience – this book is packed with handy hints and tips, charts and illustrations that will equip you in your quest to seek out the unknown and increase your chances of capturing evidence of the paranormal on film, video and audio.

ISBN: 978-1-84868-234-4 | 256 PAGES | 80 ILLUSTRATIONS | £14.99